Cézanne

ROGER FRY

Cézanne

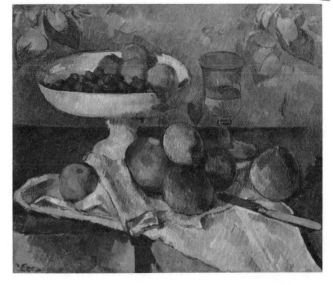

A Study of His Development

With an Introduction by Richard Shiff

The University of Chicago Press • Chicago and London

ROGER FRY (1866–1934) was an English artist and art critic who, at the invitation of J. Pierpont Morgan, was director of the Metropolitan Museum of Art in New York from 1905 to 1910. His other books include *Giovanni Bellini* (1899), an edition of Sir Joshua Reynold's *Discourses* (1935), *Henri Matisse* (1930), *Characteristics of French Art* (1932), and *Reflections on British Painting* (1934).

The University of Chicago Press, Chicago 60637
The University of Chicago Press, Ltd., London
© 1989 by The University of Chicago
All rights reserved. Originally published 1927
University of Chicago edition 1989
Printed in the United States of America

98 97 96 95 94 93 92 91 90 89 5 4 3 2 1

Library of Congress Cataloging-in-Publication Data

Fry, Roger Eliot, 1866–1934.
 Cézanne : a study of his development.

 Reprint. Originally published : New York :
Noonday Press, 1960.
 Bibliography: p.
 1. Cézanne, Paul, 1839–1906—Criticism
and interpretation. I. Title.
ND553.C33F7 1989 759.4 88-29645
ISBN 0-226-26644-3 (alk. paper)
ISBN 0-226-26645-1 (pbk. : alk. paper)

Illustrations

Publisher's Note

This book was originally published by the Hogarth Press, London, in 1927; the first American edition was published in the same year by the Macmillan Company, New York. In 1952, these presses issued a second edition. The Noonday Press of New York published a third American edition in 1958, with an introduction by Alfred Werner; this work was reissued in 1960, by which time the Noonday Press had become a subsidiary of Farrar, Straus and Cudahy, New York.

The present edition is based on the text of 1960; an introduction by Richard Shiff replaces the essay by Alfred Werner. Although effort has been made to correct misspellings and minor inconsistencies, other idiosyncrasies have been preserved because of the historical importance of Fry's text. Some of the works reproduced in this book are no longer generally known by the names that Fry used, and in these cases the list of illustrations gives the more familiar title in parentheses after Fry's title. Where Fry did not identify a painting by name, the familiar title is provided. One illustration—Fry's own copy of a self-portrait by Cézanne—is new to this edition.

We gratefully acknowledge the help of John Rewald and Jayne Warman in identifying current owners of the works reproduced, in acting as intermediary with private collectors, and in providing several photographs.

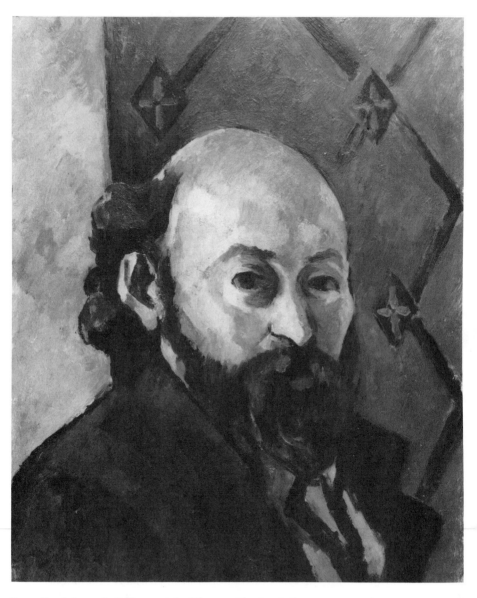

Roger Fry, A Copy of a Self-portrait by Cézanne. The Fry Collection, Courtauld Institute Galleries, London.

Painting, Writing, Handwriting
Roger Fry and Paul Cézanne

by Richard Shiff

I've begun to get a notion of Cézanne's nature and de-
velopment, but I doubt if I can express it fully . . . it's all
got to get clearer inside me before I can write.
—*Roger Fry to Helen Anrep, 1 May 1925*[1]

[The French word for handwriting, *écriture*] refers to
the rhythm of the handling of paint. [The English word]
handwriting has hardly acquired this use, but perhaps
might be adequate.
—*Roger Fry, 1928*[2]

It is only when the attention is liberated from the actual
forms which the hand is producing that the more
organic and richer rhythmic systems occur.
—*Roger Fry, 1926*[3]

Our culture has long puzzled over the status of the artifact—its
capacity to represent or to reveal, its social value and use, its sig-

1. Denys Sutton, ed., *Letters of Roger Fry,* 2 vols. (New York, 1972), 2: 568.
2. Roger Fry, "Words Wanted in Connexion with Art," in Logan Pearsall
Smith, ed., *Needed Words,* S.P.E. tract no. 31 (Oxford, 1928), 331.
3. Roger Fry, "Reflections on Handwriting," in Roger Fry and E. A. Lowe,
eds., *English Handwriting,* S.P.E. tract no. 23 (Oxford, 1926), 88.

nificance as an index of its maker, its identification as a work of art. From the ancients we inherit theories of art, poetry, and rhetoric; but their writings are not statements of criticism in the way that Roger Fry's are. The practice of art criticism, with its personalized and often hesitant evaluation of works and artists, is largely a modern phenomenon. The development of this genre of writing in the eighteenth century and beyond corresponds to increasing public involvement with the arts as modes of individual expression. As the political and psychological discourses of the nineteenth century centered on the conception of the "self," the artist became a paradigm of "self-expressiveness."

By the time Fry wrote on Cézanne it was customary to explain the expressiveness of a painting by reference to an artist's personal history, or simply to the artist's inner being, as it might be manifested in any characteristic habit or act. Painting was such an action, and in that sense it had style. In one of his early essays (1901) Fry stated that "we may regard line as a gesture which impresses us as a direct revelation of the artist's personality in the same way that handwriting does."[4] Along with his fellow connoisseurs—a tradition including Giovanni Morelli, Heinrich Wölfflin, and Bernard Berenson—Fry believed that handwriting analysis (graphology) was naturally allied to evaluation of painting and drawing: character was revealed in the smallest, simplest details. For the critic, an artist's character assumed a certain interpretable form like a character written into a novel. It also appeared in the form of characters that anyone could write, letters of the alphabet, ordinary marks made distinctive by being registered in a personal hand.

To fail to understand an artist's oeuvre would not necessarily indicate an ignorance of generalities (procedures, rules, cultural traditions), but might instead manifest weakness in the critic's

4. Roger Fry, "Giotto" (1901), *Vision and Design* (New York, 1956), 175.

own character—an inability to encounter the strength of an artist head-on, through the particularized medium of the artwork. A critic's response could be quite immediate, regardless of a work's idiosyncracy. The modern professional critic assumes, or wishes to attain, a sensibility (Fry's term) adequate to the artist's.[5] It may be that such desire to identify with artists is shared by the entirety of the modern "public," whether critically engaged or not. Despite familiar accounts that tell us of masterworks met by hostility and philistinism, it is useful to think of artist and public as deeply interdependent, each seeing in the other desired proof of a condition of freedom. Indeed, in modern democratic society artists become mirror images of their own ideal audience, persons conceived (and conceiving themselves) as free agents—free to express both feelings and taste, to like or to dislike, to sell or to buy those objects that make up their select field of experience. When artist and audience identify with each other so closely, the art that mediates between them is likely to represent (directly or indirectly) issues of common public interest. As if products of supersensitive observation, artworks seem to draw together disparate or conflicting concerns and to translate the aggregate into richly articulated discourse. Artists imagine that they communicate freely with members of a public who, in the mirroring face of the work of art, likewise see themselves as transcending social, cultural, intellectual, and psychological limitations.

If artist and public reinforce each other within this scenario (representing the mythic perfection of modern culture), what role is left to the art critic? Will the writer merely reconfirm what artist and audience already believe, praising the liberating quality of a work, exemplifying free exercise of taste and judgment?

5. Sensibility can be discerned in all human gestures, yet there will be no formulaic way of expressing it since it "corresponds to our desire for variety, multiplicity, chance, the unforeseeable"; from Roger Fry, "Sensibility" (1933), *Last Lectures* (London, 1939), 28.

A critic might instead challenge the artistic or aesthetic detachment claimed by both artist and appreciative, or even hostile, public. Doing so, however, puts the critic in an adversarial position in relation to modernist values. Such a position is common today, when many regard modernism and its myth of artistic liberation as a thing of the past. It was not so common, of course, among the generation of Fry, whose life (1866–1934) coincided with a time of intense cultural commitment to aesthetic detachment and individual artistic expression.

Without engaging in a thoroughly adversarial role, a critic's commentary can highlight issues and extend them beyond the imagination either of artist or public. Whenever this is the case, art criticism (like a work of art) assumes a creative function in its own time and remains of more than passing interest for the public of the future. Charles Baudelaire's "Painter of Modern Life" (1863) is a celebrated example. It has as its ostensible subject the life and art of Constantin Guys, who never affected the course of modernism very much. Yet, in his writing on Guys, Baudelaire created a constellation of elusive elements of modern experience—naiveté, genius that is childlike, and a transient "classical" beauty associated with fashion. This constellation reappears elsewhere in criticism and theory to become a canonical image of modernity. Baudelaire's themes are not unique to him, but his configuration of their interaction is particularly powerful; his criticism champions modernist values and yet also, in its dialectical complexity, opens onto vistas beyond modernism.

Despite great differences, there are echoes of Baudelaire in Fry, especially in the latter's concern for naive, expressive vision and for those social practices that can either foster or inhibit it (including elements of commerce and education). Fry's *Cézanne: A Study of His Development* (1927) has retained a readership just as Baudelaire's "Painter of Modern Life" has. Yet Fry's writing lacks the range and complexity of Baudelaire's. Why does he still

hold our interest? My answer in brief is this: We read Fry not only because his analysis of Cézanne's style continues to impress, but also because he, like Baudelaire, articulated a constellation of modern concerns in a manner both penetrating and suggestive.

Fry's essay on Cézanne contains many remarks that will appear extreme. For example: "If one would understand an artist, one must sooner or later come to grips with the actual material of his paintings, since it is there, *and nowhere else,* that he leaves the precise imprint of his spirit."[6] Few would deny the importance of an artistic material or medium, yet in this statement Fry goes beyond regarding the medium as a vehicle for an expressive force that might just as well find a different channel. Instead, he peremptorily defines the end of artistic representation in terms of an individual's self-expression and, at one and the same moment, locates both the means and evidence of that expression in the material features of a paint surface—in the very physical remains of the concerted effort of an eye and a hand.

Fry's critical involvement with paint surface might be linked to the fact that his own chosen career was neither as critic nor historian, but as painter. He wrote, lectured, and curated to earn a living; by predilection, he painted. His experience in the studio surely sensitized him to regard manipulated paint as a sign of expressive energy. For the modernist painter, to paint is to gesture. Yet we are not satisfied to attribute Fry's critical manner to his art, if only because history remembers him as a much greater critic than artist. There must be something more of substance to the distinct critical position he occupied, a stance usually labelled "formalist."[7]

6. From *Cézanne: A Study of His Development,* p. 49 in this volume (emphasis added). Subsequent references to *Cézanne* are included in the text.

7. The term *formalism* has a checkered history in critical discourse, in part because its root word *form* connotes both essential structure and superficial appearance.

Indeed, Fry's position was not merely a result of his acquiring the skills of a painter—or rather the habits and experience (he would prefer those terms). Instead it was linked to a prevailing sense of what we might call the historical evolution of expressiveness. Like so many other moderns, Fry developed nostalgia for a lost cultural origin, a primitive state in which one responded emotionally to and took naive aesthetic pleasure in nearly every object, producing the most naturally expressive representations. If, historically, Western primitivism was long past, primitive wonder could still be observed in one's own children. Children are naturally expressive (theirs is "real primitive art," Fry wrote[8]). But each child relives the loss of primitive expression, the loss that has already occurred in the culture at large and has been experienced by every modern adult. This loss is acted out most obviously in the field of artistic education, as the child gains the formal means that facilitate representation. Acquired skills convert what was once detached from practical concerns into a means to possible ends, including, ultimately, commercial ones. Fry wrote that "the pictures children draw are often extraordinarily expressive. But what delights them is to find they are acquiring more and more skill in producing a deceptive likeness of the object itself . . . [Soon] the original expressiveness will have vanished completely from their work."[9]

The passage from expression to skill, then, corresponds to that from child to adult and from primitive to. . . ? In an essay of 1917 on children's art, Fry offers a surprising set of alternatives for the final term of this equation, a structured relationship that he never fully developed either in this essay or elsewhere. The most obvious modern descendant of earlier primitive artists is the aca-

8. Letter to Margery Fry, 2 or 3 May 1917, *Letters of Roger Fry,* 2: 410.
9. Anonymous (Roger Fry and Desmond MacCarthy), "The Post-Impressionists," *Manet and the Post-Impressionists* (London: Grafton Galleries, 1910), 12.

demic naturalist who "specialise[s] on sheep or birch trees." But a different type of artist can be found in societies in which primitivism is still viable, and this type may well appear as a modern. This is an adult type who is capable of following unconscious impulses as well as acting self-consciously. Fry names this kind of artist—who is neither primitive nor academic—the "Formalist," one whose expression "is dominated by a passionate feeling about form."[10] Fry's critical distinction is between those who respond to objects and those who respond to form, and it guides all his critical judgments. Fry will speak of Cézanne's primitiveness, but this artist is actually a formalist, one for whom "a skull was merely a complicated variation upon the sphere" (p. 50) and in whose painting "the demand of the total construction for some vehement assertion of a rectilinear direction may do violence to anatomy" (Fry thus accounts for Cézanne's distortions of things observed; p. 57 [cf. pp. 46–47]). Fry's implicit argument is this: the primitive—or the child—will develop into either an academic (bad) or a formalist (good). The good child, having acquired an adult sensibility, becomes a formalist.

Fry believed that children (like formalists) were good by nature but corrupted by training—hence his opposition to traditional art education, which stressed achievement of polished illusionistic representations and seemed to promote the values of a kind of market exchange. This critique of modern culture is a familiar one. Fry stated its corollary: Expression was decreasing as preoccupation with instrumentality, characteristic of industrial society, increased. As a modern society of self-made plutocrats (Fry's term) supplanted an older aristocratic order, works of art, albeit made in defiance of the practical demands of everyday

10. Roger Fry, "Children's Drawings," *Burlington Magazine* 30 (June 1917): 226. Here, for the sake of the distinction Fry is developing, Giotto is not "primitive" but "formalist." Elsewhere in Fry's writings, he is "primitive."

commerce, were becoming valued not *for* aesthetic properties but merely *as* property, "symbol[s] of social distinctions." The new collectors demanded "a superficially fine art of *patine*."[11] Such refined surface was the degenerate form of the rough, expressive surfaces of children's art and of the rather strident surfaces Fry himself gave to hand-finished consumer goods, as he directed the activities of the Omega Workshops from 1913 to 1920. His Omega project was designed to reverse the tide of consumer society; it would give form back to commercial goods—fabrics, furniture, ceramicware—rather than commercialize art. Fry wrote that Omega artists "refuse to spoil the expressive quality of their work by sand-papering it down to a shop finish."[12] (With the Great War and with a certain logic, Fry's project failed because it was unable to maintain commercial viability.)

Fry supported his theories by promoting art that appeared to demonstrate them, art in which formal relations were so strong that the work could affect the viewer even without (that is, *preferably* without) the representational content being recognized. What counted was an investment of expressive energy and naive vision in the development of rhythmic line and color; thus Fry praised Islamic art and artifacts for "dramatic expressiveness unhindered by the artist's ignorance of actual form."[13] It did matter to Fry whether a picture was of an apple or a woman, but not much. If of a woman, sexual interest should never be the prime motivating force.[14]

11. Fry, "Art and Socialism" (1912–1920), *Vision and Design,* 66, 59. See also Roger Fry, *Art and Commerce* (London, 1926) for discussion of hand and machine production, with reference to the social symbolism of artifacts and the theories of Thorstein Veblen.

12. Roger Fry, "Preface," *Omega Workshops Ltd.* (catalog), c. 1914–1915.

13. Fry, "The Munich Exhibition of Mohammedan Art" (1910), *Vision and Design,* 117.

14. "As regards painting . . . the preoccupation with the female nude is [not] a result of sexual feeling. It is simply that the plasticity of the female figure is

Fry made his most extreme statement to this effect in 1924, in resistance to the developing psychoanalytic study of art (he was *au courant* regarding Freud and others, but not an adherent). Psychoanalysis of artworks was relying on interpretation of subject matter; but, wrote Fry, "to one who feels the language of pictorial form all depends on *how* it is presented, *nothing* on what."[15] Fry's pronouncement came shortly before he began work on *Cézanne: A Study of His Development*. Perhaps the psychoanalytic context encouraged him, in a contrary and even perverse gesture, to find the most value—aesthetic value—in works that avoided subjects, such as the nude, that bore the artist's own psychological investment. Fry conceived the heroic side of Cézanne's enterprise as a struggle to free his art from his obsessions rather than to use his art to explore or master them. Cézanne's art was greater when it simply escaped the eroticism for which it could find no adequate representational form (pp. 79–82). Fry associated Cézanne's later classic manner and his early and recurring romanticism with very different levels of psychological stability and artistic resolve. One of the critic's most influential (and misconstruable) pronouncements derived from this line of thought:

peculiarly adapted to pictorial design"; in Fry, letter to Robert Bridges, 23 January 1924, *Letters of Roger Fry*, 2: 548. "[Courbet's] innate plastic instinct led him irresistibly to the nude as a pretext"; from Roger Fry, "Some Questions in Aesthetics" (1926), *Transformations* (Garden City, N.Y., 1956), 48. Such statements appear particularly dated because they fail to acknowledge the problematics of gender relations as manifested by images of women.

15. Roger Fry, *The Artist and Psycho-Analysis* (London, 1924), 16. Many of Fry's similar statements are moderated and admit the significance of representational reference. He praised Rembrandt especially for being able to coordinate "plastic" and "psychological" values, although always at a certain risk; "Some Questions in Aesthetics," *Transformations*, 27–31. In essays of his last years Fry stressed the "dual nature" of painting, its creation of illusion and of formal design; see, e.g., Roger Fry, *Henri-Matisse* (London, 1930).

"Cézanne then was a Classic artist, but perhaps all great Classics are made by the repression of a Romantic" (p. 83).

For Fry, early Italian painting, non-Western art, children's art, and modern art all provided excellent examples of the dominating formal quality associated with the classic and its related primitivistic modes. Modern art was the most problematic of Fry's classical paradigms since there was little general agreement as to its proper standard of evaluation. Fry did as much as any other critic to establish norms of modern formal expression (and, predictably, he complained when this model was followed too closely [p. 46]). He is famous for having organized two startling cultural events that constituted a modernist manifesto: the "Post-impressionist" exhibitions held at the Grafton Galleries in London in 1910 and in 1912. Here he displayed works by those who had in the recent past revolutionized art in France—Cézanne, Gauguin, Van Gogh, Seurat—and coupled them with a younger avant-garde that included Matisse and Picasso. (Within this configuration, Cézanne, who was able to "re-create form from within," seemed the most "classic," whereas Van Gogh, who "became a portrayer of souls," was "romantic."[16]) Fry himself coined the term "postimpressionist" to describe the art he gathered together, and in his various subsequent writings he gave postimpressionism a meaning for its new British audience. French critics had been debating the merits of such art since the late 1880s, long in advance of Fry. The phenomenon of postimpressionism was thus by no means Fry's discovery; his chronological and geographical perspective, however, allowed him to grasp a great deal at once and to offer a synthetic view of French art from Manet to Matisse.[17]

16. Roger Fry, "The Post-Impressionists—II," *The Nation* 8 (3 December 1910): 402–3.
17. On the French articulation of the issues of "postimpressionist" (or sym-

For British and American readers, Fry's account of postimpressionism (like Baudelaire's account of modernity) became canonical. At its core was the idea that with the postimpressionist liberation from preconceived standards of naturalistic illusion, modern art regained an expressive force not often seen in Europe since Giotto and other Italian "Primitives." Many artists of the younger generation were returning self-consciously to archaistic modes of representation, a fact that made Fry uneasy. Postimpressionism, however, found its purest manifestation in the "Primitive and almost Byzantine interpretation which [Cézanne] gave naturally to the scenes of actual life . . . Cézanne's native attitude was essentially that of the Primitives" (pp. 11, 14). Fry reiterated what the French symbolist painters had already stressed: Cézanne did not return to an expressive mode deliberately; he did so because it was in his nature, he did so "unconsciously." In his various writings Fry gradually emphasized more and more the unconscious element in Cézanne's achievement of formal order, its intensity of intuition. Actually, according to Fry, Cézanne's art had not always been so natural; his early compositions, inspired by fantasy rather than observation, were "too deliberately expressive" (p. 70). To set out to be expressive, as if to enter a certain state of being at will, could only result in overbearingly rhetorical art; Fry repeatedly noted the mature Cézanne's avoidance of compositional arrangement and stylistic flourish (p. 63). With this emphasis on the natural and the "unconscious" in mind, we understand the sense in which classical art, despite its compelling formal harmony, was "without any rhetorical emphasis." [18] Nor need the classic be grand: Small works "are less moulded by

bolist) art and on the merits and disadvantages of Fry's account, see Richard Shiff, *Cézanne and the End of Impressionism* (Chicago, 1984), esp. 124–61.

18. Fry, letter to Marie Mauron, 1 February 1921, *Letters of Roger Fry,* 2: 502.

deliberate and conscious purpose. In them the profounder and more unconscious needs have full play" (p. 27).

Of the artists Fry introduced through his Grafton exhibitions, Cézanne became the obsession of his critical career. He first took serious notice of Cézanne around 1906, the year the painter died. In 1910 he published a translation of Maurice Denis's commemorative essay of 1907, which was the major French statement on the artist. Then came the Grafton exhibitions. Fry's subsequent references to Cézanne were numerous and quite substantial; *Cézanne: A Study of His Development* was the crowning summation of two decades of pondering the oeuvre the critic had come to consider as the greatest in modern painting.

Fry regarded his *Cézanne* as a scholarly essay, calling it the study of a "development," an informed historical monograph. Yet this development has little historical specificity; its direct references to details of biography or timely aesthetic issues are close to minimal, and there is hardly any mention of political events or of social context. Fry's Cézanne is decidedly an individual who speaks to other individuals, and potentially—because of this de-contextualization—to all who see and feel; this is a factor of the artist's "classicism."

Fry constructed his essay around a selection of paintings, each subjected to a formal scrutiny often featuring close observation of brushstroke and color (a single still-life, the *Compotier,* occupies nine pages [pp. 40–49]).[19] As a maker of pictures, Cézanne,

19. The selection was largely determined by what could be seen in the Paris collection of Auguste Pellerin; Fry's book grew out of his commissioned essay on the Pellerin paintings, "Le développement de Cézanne," *L'amour de l'art* 7 (December 1926): 389–418. His formal analyses remain unsurpassed for their sensitivity to Cézanne's technical innovations, especially the substitution of relationships of color for chiaroscuro. At times, however, Fry's sense of Cézanne's stylistic development leads into errors of chronology. Of the two compositions of bathers he discusses on p. 77, it is the more lightly painted (unfinished) one that is the later (fig. 45).

in Fry's eyes, became the historical equal of any other artist. Accordingly Fry always felt free to compare Cézanne to antecedent masters. He did not aim to assert any specific influence but was merely assuming that works of similar formal appearance would have been produced in similar spirit; this kind of structural comparison is a familiar feature of formalist interpretation. In a review of 1925 that reads as if a rehearsal of the themes of the definitive 1927 essay, Fry wrote that Cézanne always represented "the most direct and simplest aspect of things—the aspect, that is, of primitive art. . . . It was reserved to Cézanne to make apples on a table or the trees at the edge of a wood take on the imperturbable serenity and poise of Giotto's figure compositions." [20]

Fry did more than visually compare Cézanne to Giotto and the other early Italians; he also made a kind of manual comparison as he copied pictures by the old masters as well as by Cézanne. With characteristic specificity he discusses a Cézanne self-portrait (pp. 53–54; fig. 47) that he had himself studied in an act of intense submission (see his portrait of Cézanne, p. x). He was concerned with the expressiveness of habits of the hand that might be linked to an authentic vision extended into the smallest details, habitual movements that could yet respond to the life of the moment. (Cézanne never executed "a picture as a [preconceived] performance. Each canvas had to be a new investigation and a new solution" [p. 55]).

Fry repeatedly referred to a metaphoric handwriting—representations constructed from a rhythmic application of paint strokes (e.g., p. 42). What he said about "literal" handwriting—letters made with pen strokes—captures one of the master themes of his Cézanne essay. Handwriting was an example of those "small works" in which one often finds the purest, because

20. Roger Fry, "Cézanne at the Leicester Galleries," *The Nation and the Athenaeum* 37 (11 July 1925): 458–59.

unconscious, expression. Fry's various statements on painting and handwriting depend on an analogy: just as script becomes expressive and aesthetically forceful only when it transcends the need to render "the fixed and unvarying forms of letters," so painting becomes classic only when it transcends the standard formulas for depicting individual objects. Aesthetic handwriting responds as if unconsciously to the chance order of letters and varying length of words to produce "the more organic and richer rhythmic systems." The sensitive writer allows "deliberate aesthetic predilections to pass into unconscious manual habits."[21] The import of this last statement, which applies to both writer and painter, is less than obvious. Fry is suggesting that in the case of those who have artistic aptitude, the natural selectiveness of the eye, its unconscious attraction to certain formal relationships, is transferred immediately to the characteristic rhythmic markings of the hand. This results in eye and hand working in total harmony responsive to the harmonies to be felt in nature. In this sense Fry spoke not only of unconscious realization but of "Cézanne's idea that the artist is the means by which nature becomes self-conscious" (p. 68).[22] And from here his more general

21. Fry, "Reflections on Handwriting," 86, 88, 91. Fry used his handwriting metaphor to discuss not only genuine "expression" but also repetitious technical "performance" that he associated with commercialization of painting; Roger Fry, "Higher Commercialism in Art," *The Nation and Athenaeum* 42 (19 November 1927): 276–77. On the state of the science of graphology at the time of Fry's speculations, see Robert Saudek, *The Psychology of Handwriting* (London, 1925). Saudek states that when children learn to write "individual peculiarity very quickly modifies the original copy" of the schoolmaster's script (p. v). Robert Bridges, who sponsored Fry's commentary on handwriting, criticized Saudek for failing to distinguish between professional and amateur handwriters (Robert Bridges, *English Handwriting,* S.P.E. tract no. 28 [Oxford, 1927], 224–27), thus implicitly raising the issue of the artist's development of an ability to feign character. Saudek himself was not unaware of the problem (p. 34).

22. Fry is probably thinking here of Joachim Gasquet's report of a statement Cézanne supposedly made to him: "I will be the subjective consciousness of the

conclusion follows easily: The work of art represents both the life of the artist and the life that is in nature. These two converge, granting each other existence in the "aesthetic emotion" that the viewer, too, senses. Lives thus meet in art; and at this point—in Fry's "formalist" theory—we find the convergence of modernist notions of classicism, primitivism, and immediacy.

It might seem that in many of his own landscape and still-life paintings Fry was imitating, reductively, a number of Cézanne's technical devices, even his "handwriting." There is indication, however, that Fry thought the resemblances stemmed from direct observation of a living nature, especially when he visited Cézanne's motifs at Aix-en-Provence. His casual reflection is telling: "The odd thing is that when one paints these particular firs [a Cézannean motif] without any *parti pris* it simply becomes like the modelling of Cézanne."[23] Characteristically, Fry attributed his manner of painting—and by implication Cézanne's as well—to naive, untutored observation. Cézanne attained classical artistic purity in a contact with nature so close that it isolated him from the teachings of his contemporaries; Fry reached the same truth at a moment when he gave his intellect up to sensation.

For Fry, an artist's proper encounter with nature, his experience of form, yields generalized emotions rather than particularized instrumental ideas.[24] Such emotions are to be sensed but are not subject to adequate description. In a letter to a sympathetic listener, the critic attempted to explain his own goals as a painter, associating himself with a "classical" manner of expres-

landscape, just as my canvas will be its objective consciousness" (Joachim Gasquet, *Cézanne* [Paris, 1921], 81). The theme was later taken up in the famous essay by Maurice Merleau-Ponty, "Le Doute de Cézanne" (1945), *Sens et non-sens* (Paris, 1966), 30.

23. Letter to Vanessa Bell, 19 November 1919, *Letters of Roger Fry,* 2: 469.

24. This is a frequent theme in Fry's theoretical speculations; see, e.g., "An Essay in Aesthetics" (1909), *Vision and Design,* 16–38.

sion; these views underlie his interpretation of Cézanne, just as Cézanne assumes the role of Fry's absent painting-master: "In painting I try to express the emotions that the contemplation of forms produces in me . . . classical art [evokes] feelings derived from the contemplation of form for its own sake. . . . And what is this emotion that emanates from the contemplation of forms? I don't know. It cannot be expressed other than by the works of art."[25] With similar resignation, Fry would conclude his study of Cézanne by insisting that "analysis halts before the ultimate concrete reality of the work of art . . . we cannot in the least explain why the smallest product of [Cézanne's] hand arouses the impression of being a revelation of the highest importance" (pp. 83–84).

Fry never doubted that there must be a gap between understanding and sensation. He did not think his activity as a critic could supersede what he might learn as a painter, nor even reproduce that knowledge. In this relationship of unequals, he privileged painting, not criticism. His preferred mode of writing was handwriting.

Ironically, Fry recognized that his writing challenged the public much more than his painting did. His art was tirelessly experimental, verging on both imitative eclecticism and the primitivism he admired in Cézanne and others; yet it failed to excite his peers deeply ("as a painter he has his ups and downs"[26]). Fry, who was socially liberated and intellectually innovative, could not match the artistic liberation of his idol Cézanne, that eccentric conservative. His writing was expressive enough to help us see this.

25. Letter to Marie Mauron, 23 November 1920, *Letters of Roger Fry,* 2: 496–97. Cf. Fry, "Retrospect" (1920), *Vision and Design,* 301–2. Elsewhere, Fry speculated that the aesthetic emotion might amount to a vague generalized residue of emotions associated with ordinary life experiences; *The Artist and Psycho-Analysis,* 19–20.

26. Anonymous, "Bosch—And Mr. Roger Fry," *The Nation and Athenaeum* 41 (13 August 1927): 643.

Selected Bibliography

Locating Fry's writings

Donald A. Laing. *Roger Fry: An Annotated Bibliography of the Published Writings.* New York, 1979.

Fry's letters

Denys Sutton, ed. *Letters of Roger Fry.* 2 vols. London, 1972.

Fry's biography

Virginia Woolf. *Roger Fry: A Biography.* London, 1940.
Frances Spalding. *Roger Fry: Art and Life.* London, 1980.

Fry as critic

Jacqueline V. Falkenheim. *Roger Fry and the Beginnings of Formalist Art Criticism.* Ann Arbor, 1980.
Linda Hutcheon. *Formalism and the Freudian Aesthetic: The Example of Charles Mauron.* Cambridge, 1984. Pp. 15–94.
Richard Shiff. *Cézanne and the End of Impressionism.* Chicago, 1984. Pp. 142–61.
Marit Werenskiold. *The Concept of Expressionism: Origin and Metamorphoses.* Ronald Walford, trans. Oslo, 1984. Pp. 5–34, 215–19.

Fry in relation to British art

Simon Watney. *English Post-Impressionism.* London, 1980.
Charles Harrison. *English Art and Modernism, 1900–1939.* London, 1981.

Fry and the Omega Workshops

Judith Collins. *The Omega Workshops.* Chicago, 1984.

Preface to First Edition

About three years ago M. Waldemar George, then editor of "l'Amour de l'Art," desiring to bring out in his journal a complete series of reproductions of the Cézannes in M. Pellerin's collection, asked me to write the accompanying text. Difficulties arose which prevented the scheme from being carried out fully and we were obliged to be content with a selection. In this reduced form my essay and such illustrations as could be procured constituted last December's number of "l'Amour de l'Art." This essay is the basis of the present work, but it has been considerably enlarged. M. Pellerin's collection is so much the most representative of all the various phases of Cézanne's art in existence, that a study of it is essential to understanding his development. It does not, therefore, interfere with the general bearing of the present essay that the majority of examples chosen are drawn thence.

My thanks are due to the Editor of "l'Amour de l'Art" for permitting the use of the blocks used in that journal, to M. Simon Lévy for valuable advice, and to Dr. Heyligers for allowing me to consult his collection of photographs of Cézanne's works.

Roger Fry
August, 1927

Important Dates in Cézanne's Life

1839	Born at Aix-en-Provence.
1861	First visit to Paris and return to Aix.
1862	Settled in Paris to study painting.
1863	Portraits of his father and Achille l'Empéraire (Figs. 4 and 5).
1869–1870	At Aix and L'Estaque.
1872–1873	At Auvers with Pissarro.
1877	"Le Compotier" (Fig. 16). "The Bathers" (Fig. 24). Portrait of M. Choquet. Exhibit with the Impressionists.
1888	Portrait of Mme. Cézanne in red dress (Fig. 34).
1891–1892	"The Cardplayers" (Figs. 36 and 37).
1895	Portrait of M. Geffroy (Fig. 35). Exhibition of his works at M. Vollard's.
1904	Portrait of Vallier (Fig. 44). Retrospective exhibition of his works at the Salon d'Automne.
1906	Died at Aix

Cézanne

"L'art est une harmonie parallèle à la nature."
Paul Cézanne, quoted by M. Joachim Gasquet.

I

Those artists among us whose formation took place before the war recognize Cézanne as their tribal deity, and their totem. In their communions they absorb his essence and nourish therewith their spiritual being—at least they would do this—did they, like primitive man, know the efficient magic ritual. We believe in any case that in our art we incorporate something of his essential quality. Yet when, before one of his works we try to press into closer contact with his spirit there is a risk that the needs of our own personal expression may so far have distorted our conception of his nature, that we see not so much his expression as the distorted image of it which has gradually taken its place in our own minds. For Cézanne has not come to us directly; we have almost all of us approached him through some mediatory and more easily accessible personality such as Van Gogh's.

If we only knew something about the rhythm of man's spiritual life we might understand why every great spiritual discovery—and almost in proportion to its greatness—has to undergo this deforming process; why gods lose something of their real charac-

1

ter in the process of divination; why Jesus implies St. Paul; why St. Francis must have his brother Elias; why Cézanne already before his death saw Gauguin "parading his sensation before the public." And what would Cézanne have said of his spiritual progeny to-day, before a Picasso, a Dufy, a Vlaminck or a Friesz? This question forced itself on me with greater insistence when at the invitation of "l'Amour de l'Art" I agreed to make a detailed study of the largest and most representative collection of Cézanne's works in existence. Because what surprised me most—when once I had, so to speak, depolarized his works, when I had removed the scales of vague and distorted memories; when, at last, I seemed to be face to face with the artist himself—what surprised me was the profound difference between Cézanne's message and what we have made of it. I had to admit to myself how much nearer Cézanne was to Poussin than to the *Salon d'Automne*.

Every year the effectiveness of our art becomes more apparent. To describe a masterpiece of the *Salon d'Automne* or of some equivalent English exhibition one would have to use positive terms; to describe Cézanne's works, I find myself, like a mediaeval mystic before the divine reality, reduced to negative terms. I have to say first what it is not. Cézanne is not decorative like so many of our most gifted contemporaries; he is not what artists call "strong"—and goodness knows what strength some of us display; he has not the gift to seize hold directly on an idea and express it with an emphasis which renders it immediately apparent; he seems indeed hardly to arrive at the comprehension of his theme till the very end of the work; there is always something still lurking behind the expression, something he would grasp if he could. In short he is not perfect, and of many modern works one might predicate perfection. Many modern painters have intense assurance; no one was less assured than Cézanne. He often feels his way so cautiously that we should call him timid were it

not that his tentatives prove his desperate courage in face of the elusive theme.

If I try to use positive terms they still are of the nature of limitations. Cézanne is so discreet, so little inclined to risk a definite statement for fear of being arrogant; he is so immensely humble; he never dares trust to his acquired knowledge; the conviction behind each brush stroke has to be won from nature at every step, and he will do nothing except at the dictation of a conviction which arises within him as the result of contemplation.

For him, as I understand his work, the ultimate synthesis of a design was never revealed in a flash; rather he approached it with infinite precautions, stalking it, as it were, now from one point of view, now from another, and always in fear lest a premature definition might deprive it of something of its total complexity. For him the synthesis was an asymptote toward which he was for ever approaching without ever quite reaching it; it was a reality, incapable of complete realization.

That at least is how I would endeavour to outline the specific character of Cézanne's art. But when one speaks thus of Cézanne it is necessary to explain that all this refers to Cézanne in the plenitude of his development, after many years of research, after the failure of many attempts in different directions—to Cézanne when he had discovered his own personality. Hardly anything of what has been said above would be true of Cézanne in his youth.

We are so familiar with the picture which those who knew him have given us of Cézanne as an old man, that we think of him inevitably in that light. We picture him in his retirement at Aix, disillusioned, shy, living in obscurity, avoiding all contact with the world—for all his timidity, capable of a sudden sally if attacked in his den—half-conscious of the immensity of his genius and yet ridiculously humble before accepted authority, or exaggeratedly pleased with any recognition—we know all this so well, it com-

poses for us so striking a portrait that it is difficult to picture Cézanne as a young man contemptuous of authority, full of Mediterranean exuberance, confident of success, bursting with ambition and assurance but already devoured by the purest passion for his art. Such was, however, the young Cézanne who came up from Provence to conquer Paris, who was recognized as the *enfant terrible* of the youngest group. His biting sarcasms against official art went the round of the studios. He seemed the most extreme, the most impossible of revolutionaries. One must imagine him at this period as having an abounding self-confidence, a paradoxical vehemence of expression which might have seemed like a pose to anyone who could not detect the intensity and purity of the passion which inspired him. If to all this, we add two characteristics the most unfortunate possible for anyone finding himself in such a position, namely an exaggerated sensitiveness which left him defenceless against harsh criticism and an exceptional want of even ordinary competence in the representation of those images which his feverish imagination engendered, we can see what tragic possibilities Cézanne's situation implied.

His works record for us the unfolding of this drama. The masterpieces of the later decades of his life already foreshadowed the triumphal close of his evergrowing posthumous fame. But, that these masterpieces should have been what they are, required all the peculiar circumstances which moulded his native gift. And among these circumstances one should, I think, lay special stress on the part played in his life by the startling failure of his early appearances in picture exhibitions. If one imagines such early works as the *Autopsy,* the *Lazarus* or the *Assassination* to have been acclaimed as works of genius by the art critics of the day and imposed by them on the public, one would have predicted for Cézanne the probability of a much more commonplace career than that which he actually traversed. To what a sequence these works might have been the prelude! What grandiose and

ambitious compositions we might have had—compositions in which the artist would have abandoned himself to the extravagance of an imagery, Hugoesque in its exuberance, and Baudelairean in its cruelty!

II

But we must return from these speculations to consider the beginnings of Cézanne's sentimental education. The fact that as a boy in the public school at Aix he formed a close and intimate friendship with the youthful Emile Zola has perhaps more importance than has generally been allowed. In any case it adds certain vivid and picturesque contrasts to the drama of his artistic evolution. We get from reminiscences a sympathetic vision of these two little southerners who shared in a soaring ambition and a passionate devotion to the life of the spirit. It was Virgil that, like Dante, they chose for guide, but a guide to their own native country. Nowhere better than round Aix, among the sunburnt rocks and the aromatic scrub and ilex groves of that landscape could they find the clue to the classic sentiment for landscape, and it was indeed that sentiment which Cézanne was destined to recreate for the modern world not in terms of reminiscence of past works of art, but as a new and potent reality. Thus the two boys escaped on holidays for long days of wandering over the mountains, mutually exciting each other by their common dream of artistic glory.

And it was perhaps the more precocious and superficial Zola who took the lead; for if in after years he showed how ill he understood the claims of artistic inspiration one has only to read his *l'OEuvre* to see the immensity and generosity of his original conception. There was certainly nothing vulgar or interested in the dreams of these two schoolboys. But the curves described by their careers are admirably contrasted. Starting with the same

ambitions, one arrived rapidly at a striking success and a world-wide fame, the other sunk into total failure and neglect; would indeed, one guesses, have sunk into total misery and destitution or into some scarcely less deplorable means of living, if he had not had the good fortune to inherit a small competence. The one who arrived at a great position became progressively less and less of an artist, more and more a worshipper of big editions, until in the end he prostrated himself before the public and its press. The other became more and more intensely an artist, and though almost unknown in his lifetime has become already to his near posterity a heroic figure.

Our romanticism makes us want everything of a piece and writers have in consequence contrasted too artificially this hero-ism of the painter with the puerile vanity of the writer. But nature is far too rich and curious to be fitted to the simple formula of heroes and traitors, and the drama loses much of its interest if one fails to recognize that the pure artist of Aix became a disillu-sioned, suspicious and grumbling misanthrope, and that the au-thor of so many common and ill-written books was also the author of *J'accuse*. In saying that, no political question is involved. What-ever the rights and wrongs of the case may have been, the ges-ture of a man who risked popularity, wealth, perhaps life itself, out of a disinterested passion for justice, is no way commonplace, though it met with nothing but contempt from his ancient friend. This no doubt is only a variation on the theme of the drama of Cézanne, but it is one which adds a certain piquancy to it. The mere fact that the two devoted friends of youth drifted into some-thing like mutual hostility throws a light on their characters. Only when he heard of the death of Zola, whom he had not seen for years, did something of the old feeling return to Cézanne.

Cézanne's father was a well-to-do banker in the little provincial capital of Aix. He enjoyed the social prestige and shared the so-

cial prejudices of the provincial *bourgeoisie,* with the result that Cézanne's biography begins, according to the classic ritual, with the struggle against parental authority. The young Paul, for all his internal ebullition, was naturally timid and submissive, and on two occasions he obediently attempted to satisfy his father's desires and to become a banker. But at last the sight of so many illustrations in the margins of his ledgers persuaded the father to give up the desperate attempt, and Cézanne was allowed to settle definitively in Paris in order to learn his craft.

We must imagine him at this stage profoundly convinced of the authenticity of his inspiration and like so many others filled with a confidence founded on ignorance of difficulties. He had of course begun to paint on his own account while he was still dutifully attempting to learn banking at Aix. It was there on four panels of his father's house that he painted those immense figures of the *Seasons* which are not without a certain primitive grandeur, and certainly indicate no lack of confidence. That he signed them with Ingres' name shows a curious youthful exuberance and playful insolence. But there are other works of this period which show him already in a more humble and serious vein. Exact copies of Dutch interiors, or careful and elaborate still-lifes in the Dutch manner slightly reminiscent of Kalf. But Paris brought out in him the other side of his character, his vehement and paradoxical revolutionary intransigence. Courbet had already set the note of the artist's arrogance to the public and Cézanne, who knew and admired him, became subject to his influence. But, alas, he lacked that excellent rhinoceros hide which protected Courbet. So far indeed was he from possessing any sort of hide, that his fellow students nicknamed him *"l'écorché,"* the man without any skin to protect his sensitiveness from the strokes of fate and the malice of his fellows.

III

It was in 1863 that Cézanne settled in Paris. It was a year of crucial importance in the history of modern art—the year in which Napoleon III, listening to the well-grounded complaints against the narrowness of official art of the Salon, ordered the establishment of the *Salon des Réfusés,* where those artists who had failed to get placed by the official jury might show their works. The success and the scandal of the exhibition was Manet's *"Déjeuner sur l'herbe."* This composition, seen by our artist in all the fervour of his youthful revolutionary enthusiasm, exercised a profound influence on his art. The motive of the picture haunted him throughout his life and he never gave up the hope of realizing a great design, conceived in a similar spirit. It is indeed an idea that constantly recurs in the history of art; that of contrasting, in a single composition, the brilliance of nude flesh and the beauties of landscape—it is the eternal dream of an earthly paradise. But the earthly paradises of the romantic school had ceased to be convincing. They had become merely legendary conventions. Realism, Courbet's new war cry, was the order of the day, and realism demanded a sharper and more definite vision, and one nearer to the experiences of actual life. The rhetoric of the romantics, the shepherdesses of Corot and their kindred seemed too superficial and empty. It was at this moment in the development of sentiment that Manet, looking at the old masters in the Louvre with a fresh and enquiring eye, saw that in such a picture as Giorgione's *Fête champêtre* the theme was handled more frankly; that Giorgione had taken the liberty, denied to modern artists, to construct his paradise from the facts of the world around him and paint nude figures of women and young men in their ordinary clothes, side by side, in a lyrical landscape setting; in fact to treat the earthly paradise as a quite actual and possible picnic.

All that Manet did was to translate this motive of sixteenth-century Italy into nineteenth-century French, but the public, who were protected from ever really seeing Giorgione by the veil of historical sentiment through which they look on the art of the past, were horrified. The feeling threatened to break out into open violence and to become almost a political event, so intolerant is the public of whatever escapes its comprehension and yet imposes on it by the conviction and sincerity of the artist.

The influence which this picture exercised upon Cézanne lay far more in the treatment of the theme, in the idea of painting a modern lyric, than in the formal qualities or the specific vision shown in Manet's work. For Manet's imagination was purely visual. There was nothing visionary about his invention. He did not attempt to create from within images expressive of a poetical idea. Now Cézanne at this period believed himself to be a visionary. His imagination, nourished on poetry, aimed at something besides the plastic interpretation of actual appearances. He worked, above all, to find expression for the agitations of his inner life, and, without making literary pictures in the bad sense of the word, he sought to express himself as much by the choice and implications of his figures as by the plastic exposition of their forms. Manet then, with his literal realistic representation, could not serve his need, and it was rather to Delacroix that Cézanne turned for the counsels he required—to Delacroix and also to the old masters such as Veronese and Rubens, with whom Delacroix had himself gone to school. It is true that alongside of these attempts at imaginative invention, Cézanne was exercising himself in more purely pictorial genres, in portraits and still-life. And in these the influence of Courbet is predominant. Still on the whole the main preoccupation of Cézanne's youth was along the more ambitious lines of poetical invention. He thought of himself as a visionary.

IV

The *Lazarus*, the *Autopsy*, the *Banquet* and a number of other compositions are there to prove how large a part of Cézanne's activities were absorbed by this preoccupation during his early period. In all these works he set out to realize his inner vision without reference to actual models. He never altogether gave up this ambition to find within himself the point of departure for his compositions, but, as we shall see, more and more he resigned himself to accepting the thing seen as the nucleus of crystallization in place of poetical inspiration. One cannot doubt that little by little he had to admit to himself that he did not possess the special gifts for such a gestation of poetical ideas, and for transmuting them into coherent plastic images.

Not that his inner visions, in themselves, were ever commonplace or vulgar. They show indeed extraordinary dramatic force, a reckless daring born of intense inner conviction and above all a strangeness and unfamiliarity, which suggests something like hallucination. But all these qualities of his inner vision were continually hampered and obstructed by Cézanne's incapacity to give sufficient verisimilitude to the personae of his drama. With all his rare endowments, he happened to lack the comparatively common gift of illustration, the gift that any draughtsman for the illustrated papers learns in a school of commercial art; whereas, to realize such visions as Cézanne's required this gift in a high degree. He needed such a gift as Rubens's, the gift of providing for the inner vision straight away, without effort and research, an adequate formula for any object offered to the eye in any aspect and under any conditions of light and shade, and moreover to relate these objects within a credible space. How far Cézanne was from that, we may judge from any of the pictures cited above, but perhaps best of all from one of the most ambitious and instructive of all the series, the *Banquet* in the Pellerin Collection. It is

unfortunate that no photograph is available of this work, but it is so important for the understanding of this question, that it demands our consideration.

It is no use to deny that Cézanne has made a very poor job of it. As in some pictures of Tintoretto's, a long table runs from the left foreground in rather sharp perspective. At this the guests are seated or rather disport themselves in a variety of extravagant attitudes—for the orgiastic note is emphasized. The table appears to stand solidly enough in the near foreground, but further away all support is wanting, and it seems projected into the blue sky. This, however, does not prevent a column from rising to the left and supporting a balcony which runs across the top of the picture. Musicians appear in this balcony whence a huge velum hangs down across the sky. But not only is the whole scene thus wanting in verisimilitude, there is a want of proportion in the figures which is really disquieting! The head of a woman seated half-way down the table is not only about six times as large as the head of a man leaning on the table beside her, but it is at least three times as large as the head of a woman right in the foreground. One could continue this catalogue of visual impossibilities through all parts of the picture. But there are also the strangest naïvetés, as for instance placing a nude foot sticking into the picture in the foreground. The effect is that of a foot growing from the edge of the frame. Such an invention might not shock us too much in a purely primitive design, but in so elaborately Baroque a composition as this, it strikes a strangely inharmonious note. It invalidates the pretensions of such elaborate and artificial systems of design. But this very fact illuminates for us a most important characteristic of Cézanne's genius, namely the struggle within him between the Baroque contortions and involutions with which his inner visions presented themselves to his mind, and the extreme simplicity, the Primitive or almost Byzantine interpretation which he gave naturally to the scenes of actual life.

11

But before investigating this further let us return to our analysis of the *Banquet*. From the description given above it will be apparent that the main theme is influenced by vague reminiscences of Veronese's great compositions. It is essentially a Venetian conception, but the rhythm is quite different. All the personages are contorted by violent and agitated movements, the contours are rendered in swelling curves and with an exaggerated emphasis. All this reminds one rather of Delacroix, but with even more vehemence and abandonment than his. The colour, too, shows in parts the influence of Delacroix; one recognizes his heavy emerald greens, his violets and his Prussian blues. But however inferior Cézanne shows himself to Delacroix in the general conduct of his design and in verisimilitude and compositional skill, he surpasses him altogether in colour. The modulations are rich and exquisitely varied. The blue of the sky combines luminosity with a surprising intensity. The velum which hangs across it is an unforgettable discovery. Its rose-violet is tinged with all the colours of the sky, it is bathed in light, shimmering with reflections, and yet it flaunts itself sumptuously against the blue atmosphere. A negro bringing in a huge silver vase in the foreground is another astonishing chromatic invention, bringing as it does into the orgy of brilliant colour a cool greyness as unexpected as it is delicious.

The paste of the picture is thick with successive layers and retouches. One can see the traces of determined labour and of the painful effort which the endeavour to realize his dream cost the artist. But none the less the touches are always frank and deliberate, the colour fresh and pure, whereby one can measure the heroism of this extraordinary man who could go on making the most absurd statements about appearances with such uncompromising frankness, such desperate affirmation. One recognizes, too, the one gift which never failed him, his impeccable colour sense. Never once even while he was labouring desperately to

achieve some coherence of presentation, some semblance of ver-isimilitude, did he put down a touch, not only that was inharmonious, but that did not increase the richness of an original chromatic chord. It is in his colour that we must look, perhaps, for the most fundamental quality and the primary inspiration of his plastic creation. His colour is the one quality in Cézanne which remains supremely great under all conditions. This picture is perhaps one of the earliest in which Cézanne seems to have anticipated what was destined to be one of his greatest contributions to art; namely, his conception of colour not as an adjunct to form, as something imposed upon form, but as itself the direct exponent of form.

We cannot indeed measure the character of Cézanne's visionary conceptions by the *Banquet* alone. That, for all its strangeness, follows the general theatrical scenes of the later Venetians. His spirit was haunted by more terrible and disquieting images. At times the truculence of his mood led him to adopt a frankly melodramatic pretext. Such is the *Assassination,* where two men are seen, one ferociously stabbing, the other crushing the body of their prone victim. The scene is fitfully illuminated against a background of lurid darkness. It is a theme that might have tempted a Gustave Doré, but never, one would have said, the painter of the *Cardplayers,* did one know him only from the works of his maturity. But at this period the turbulence of his romantic moods found relief in many such tragically dramatic pretexts. The *Lazarus* and the *Autopsy* give us a measure of this aspect of his nature. It is no longer Delacroix who can guide him in this tenebrous limbo, it is rather Daumier, or Tintoretto—it would have been, above all, El Greco, had he known him at this epoch. There seems, however, no evidence that he did, and it remains something of a marvel how much in the *Lazarus* he seems to divine El Greco through the medium of Tintoretto.

In the *Lazarus,* Fig. 1, the composition is definitely in the seven-

13

teenth-century tradition. Unfortunately, Cézanne had never been trained—as indeed no modern artist is—in the methods of that tradition. He lacked therefore all that slowly acquired and erudite science which the great masters of the Baroque had at their disposal. He had perforce but the vaguest idea of how the older masters understood the working out of those grand constructions in which the plastic movements follow one another in an unbroken and ever varied sequence throughout the whole of the picture-space—constructions which stimulate the imagination to the freest movements in depth. Cézanne guessed at something of this Baroque idea. He saw that the effect of such compositions was generally got by arranging forms along a line receding diagonally into the picture space, and so here he establishes such a receding line and emphasizes it by the outstretched arm of the Christ. He tries in that figure to get something of the imposing effect of Baroque foreshortening. But everywhere his naïve manner threatens to destroy the illusion. Most of all does he fail in the maladroit placing of the figures of Lazarus and his sister, awkwardly pressed into the bottom corner of design, with an effect which would be comic did not the artist convince us throughout of his passionate conviction. It is the same failure as in the *Banquet* to keep throughout the grandiose pretensions of such a style. Cézanne remained always a true Provençal, and in Provence, as has often been pointed out, the distinction of the classes is hardly felt. Though Cézanne belonged to the *bourgeoisie,* there was much of the simplicity and directness of the peasant and the artisan in his outlook. He was fascinated by the splendour and the expressive power of the Baroque masters, he had little understanding of the social ambience, of the conventions of manner and bearing which they took for granted. As we shall see abundantly Cézanne's native attitude was essentially that of the Primitives; it had their blunt directness of approach, their want of ceremony. What he found in the Baroque painters was the re-

sponse to his agitated, romantic exaltation of mood; he understood neither their conventions nor the extraordinary erudition of their art. Ignorant of the difficulties which that elaborate traditional method implied, we see him struggling desperately to accomplish what lay quite outside his natural bias by sheer, desperate courage and also with a sincerity which denied him altogether the resources of pastiche. It is this sincerity which, even here, saves whatever is possible and transmits to the spectator something of the spiritual fervour in which it was conceived. That vehemence comes out also in the truculent handling of the paint, which is laid on in a full impasto with giant sweeps of a large, heavily-loaded brush.

The colour, too, is intensely personal. Black and white predominate. The black often a dead black, the white scarcely toned. The nude figures here are entirely in this menacing *grisaille*, against which notes of vermilion tell with a metallic clang. Pale sky-blue and celadon green complete this unusual chord. The method is as elementary as that of some early Gothic stained glass window. It is the exact reverse of that complex orchestration of infinitely gradated colour which we associate with Cézanne's work, which is already adumbrated in the *Banquet*. This method of the *Lazarus* suggests the influence on our artist of some idea of dramatic colour—the attempt to convey by the shock of these masses of unbroken colour—and almost by some direct physiological effect on us—the tragic emotion at which he aimed.

In the *Autopsy* (Fig. 2) we find a similar technique. One can well understand that the hospital at Aix for which it was destined, refused with indignation a composition in which the surgeon's art is revealed as belonging to the nightmare visions of an Edgar Allen Poe. Without losing all air of verisimilitude, these people look like diabolical maniacs engaged in eviscerating a corpse. Even the incompetence of the representation, the total want of

proportion in the figures does not check the urge of Cézanne's creative effort or obscure the macabre horror of the sentiment.

As strong as imaginative impulse finds its issue in quite another direction in the *Pasha* (Fig. 3). The naïvely erotic inspiration of this picture has suggested to the artist an operatic phantasmagoria so absurd, so unconvincing, that, if the art of Cézanne admitted the possibility of irony, we might imagine it to be a parody of Baroque pretentions. But, not only does the concentrated vehemence, the fanatical determination of his handling contradict such an interpretation at every point, everything brings us the conviction that such ideas were foreign to his nature. Not that we must think that Cézanne, for all his genuine simplicity, was anything of a fool. For all the immense seriousness of his art, he was not lacking in humour. Even his repeated ejaculation *"Moi qui suis faible dans la vie"* implied no want of shrewd and often pregnant good sense. He had indeed much of the sly malice of the Southern peasant; but the kind of sophisticated wit which would lead to ironical compositions, the wit of the Parisian, was not his (*"L'esprit, voyez vous, m'em. . . ."*).

We are bound, then, to take quite seriously this nude woman squatting toad-like on the sumptuous bed, this exaggeratedly vulgar theatrical *décor,* and this coarse "amateur," who contemplates with avidity her opulent nudity. What a strange progeny of the erotic *"poesie"* of Giorgione and Titian! Here all lyrical feeling is lacking, and it is difficult to find, in default of irony, what kind of mood inspires the invention. Nothing is more difficult to read, more disquieting than this composition. And yet the vision, clumsy and almost ridiculous as it is, imposes itself upon us by its indubitable accent of sincerity. Before this picture one cannot suspect Cézanne of playing a game, one feels sure that everything in it is the outcome of a powerful inner conviction which the artist is endeavouring to express in all seriousness. Here, too, as elsewhere, there is one quality about which we have no doubt or

hesitation, the quality of colour. And in that respect it is of capital importance for the work of this period. In the other Baroque pictures which we have studied the colour was of extreme simplicity and based on black-and-white relieved with a few strong local colours. Here, though the composition is again in the Baroque taste, the colour is quite different. As in the *Banquet,* we guess at that profound science of plastic colour which Cézanne afterwards elaborated, and which plays so predominant a part in his means of expression. The leaden greys, the degraded rose violets, and the clear tones of the flesh are orchestrated with great complexity and subtlety of gradation. Especially in the dull red of the curtain to the left one sees already his method of a systematic sequence of colour changes in passing from the lights to the shadows of the folds. Already here he spreads his special atmosphere over the canvas. Already we find that indefinable blue greyness permeating the shadows, enveloping the local colours and toning the bareness of even the frankest, most uncompromising statements. One guesses already at the extraordinary originality and acuity of Cézanne's chromatic sensibility.

V

The works of the early period which we have just been considering were all conceived from the data of the inner vision; they were the result of Cézanne's invention rather than his direct observation of nature. We have seen with what determination he pursued this route, although it would seem that he had neither the natural gifts nor the traditional science necessary to attain his end. But alongside of these lyrico-dramatic compositions we find a series of portraits of a very different character. This series goes back indeed to the earliest period, to the portraits of the artist's father and of the painter *l'Emperaire;* both of the year 1863. We have seen that in the imaginative designs Cé-

zanne sought to rival the great composers of the seventeenth century. For the portraits he turned elsewhere. In these he approaches his subject without any such preconceptions of what a picture should be. His attitude is simple, almost naïve, with the consequence that he reveals the fundamental characteristics of his genius far more clearly than in his more ambitious works. Before the model he forgot the Baroque; he did not search as Rubens did to find a pose and a setting which would give the opportunity for movements in depth. He rather accepted the figure as it presented itself to him. He places his model in the centre of the canvas and often full face.

These two pictures of the same year show that, as was natural at this early stage, Cézanne was still undecided as to his direction, for they are very different in conception. For the *Portrait of the Artist's Father* (Fig. 4) one has no need to seek further than Courbet for the general idea and for the technique. One cannot doubt that Courbet's painting appealed deeply to a man as vehement, as convinced, and as dogmatic as the young Cézanne. Courbet's was already that *facture couillarde,* that "spunky handling" on which Cézanne prided himself. And one must admit that this portrait justifies the pride and intransigeance of the painter. Naturally he had not at this period all the science of a Courbet. Beside him the young Cézanne appears too crude in conception, too summary in his handling, a little clumsy perhaps, but none the less he has known how to place and establish his volumes with a surprising assurance and authority. He gives to the figure already a monumental air which is new in the art of the nineteenth century, something which recalls the great Primitives. The handling with its great sweeps of the palette knife in a rich paste shows the influence of Courbet, but the tonality is more daringly frank. Already it is in the colour that Cézanne asserts most decidedly his originality and the authenticity of his gift. The data of vision are extremely simplified. He takes from the local colours of the flesh,

the hat, the dress and the shoes, a few simple notes, out of which the harmony is composed. And so rightly are the notes chosen that, simple as it is, the harmony which they establish is of a surprising force and resonance. We have the warm blacks of the waistcoat and the cap, the bistres of the floor and wall, an exquisite pure grey in the trousers, and a paler grey in the paper which the model reads, the whites and dull roses of the chair back, and against these neutrals there stand out the warm richness of the flesh tones, the orange brown of the shoes, and one note of dark emerald green in the still-life painting placed with rather elementary symmetry, immediately behind the head. The extreme clarity and luminosity of these sober colours, the fact that each has the utmost possible intensity for a given luminosity, shows how essentially a painter Cézanne was by nature. Again, by the vehemence and impetuosity of his handling, he has managed to avoid the effect of monotony which so schematic a treatment might easily have produced.

If, already in the portrait of his father, Cézanne distinguishes himself from the artists of his day by the monumental disposition of the volumes, the portrait of the painter *Achille l'Emperaire* (Fig. 5) lies so far from the familiar track that it may well have seemed disquieting to any of his contemporaries who may have seen it. For such, the question "madness or genius?" may well have pressed itself uneasily. For us, with our knowledge of his subsequent work, the answer is easy enough, but we might well be embarrassed if we had nothing else to go by.

Cézanne has posed this unfortunate creature, with his enormous head balanced on his withered body, in the same chair that he used for the portrait of his father. But this time the model is seen full face: everything except the movement of head and hands is rigidly symmetrical. The composition is almost as elementary as that of a Byzantine icon. Nothing in the art of modern times had suggested such a disposition. Cézanne reveals thus at

the beginning of his career his innate tendency towards such a primitive approach to the subject, a tendency which he tried to contradict in his Baroque compositions, but which definitively returns upon him in his later developments. The Byzantine austerity of design in the portrait of l'Emperaire is, however, not supported by the texture, which is noticeably free and agitated. The impasto is heavily loaded, and is vehemently put on with an almost declamatory gesture.

The psychology of this picture is full of interest for our appreciation of Cézanne's character at this period. He shows himself much more willful and determined than sensitive. No doubt he was too serious to be suspected of making fun of his unfortunate fellow artist, but he shows none the less a certain indifference to his model in presenting him thus hieratically on so large a canvas. By doing so he increases the impression of monstrosity. One almost feels as though he had seized the opportunity of his friend's deformity to manifest his genius and proclaim his unconcern with all but his own powerful conviction.

The other portraits of this series have all more or less the same characteristics. In all, black is largely used to heighten the luminosity of the flesh tones. The volumes are firmly established and defined with broad, sweeping strokes of the palette knife in a thick paste. The general character of the head is finely seized, but it is stated with more vigour than sensibility. Cézanne shows here the same exuberant, determined, wilful nature. Perhaps the climax of this manner is reached in the *Head of a Bearded Man* (Fig. 6). I think this may be portrait of himself. If so it is the least searching interpretation of his own physiognomy to be found among the many examples of his self-portraits. He has melodramatized himself, exaggerating the protrusion of his brow and the menacing expression of the eyes, giving to it the truculence of his own mood. In all this it barely, if at all, escapes vulgarity, and is one of the very few works by him which we must call

frankly bad. It reminds one in its exaggerated bravura of some of the over-expressive, would-be romantic heads of Pietro della Vecchia. The defiant mood persists even to the signature, which is in flaunting vermilion capitals. This tendency towards rhetoric of pose or expression persists in many of the portraits of this series, but Cézanne's innate qualities generally prevail over his assertiveness. The colour is generally sober, with rich yellow and red ochres playing against blacks and greys. And in all, in spite of the saturation and richness of the tints, he keeps full luminosity by the frankness and directness of his handling.

One of the best of the series is that which represents an *Advocate in his Robes* (Fig. 7) in the act of pleading. The dramatic idea is not perhaps subtly conceived or very strikingly expressed; one could never compare it in this respect to a Daumier. But then, in spite of his youthful ambition to excel in expressive dramatic design, Cézanne was always more plastic than psychological. But here at least the forms are interpreted with a more curious, more alert sensibility. He has evidently forgotten to be impressive and to impose his own personality, and here the colour is even more remarkable than in most, with its rich olive flesh tones against a background of white paint plastered heavily on the canvas. Even in the reproduction one can guess at something of the reckless vehemence of the handling of this period, of that celebrated *peinture couillarde* which he was destined to abandon so entirely later on.

These portraits are perhaps of more interest as revelations of Cézanne's state of mind at this period than of value for any decisive achievement. But as we advance in the series a gradual change is seen. This becomes clearly apparent in the *Portrait of the Artist* (Fig. 8), which must date from the end of the 'sixties. There is still the confident slashing brushwork in a full impasto, the same vehement emphasis, but there is already a far subtler, more inquiring and sensitive apprehension of the forms, a new

21

delicacy in the transitions of tone, a new curiosity about the contours. The result is that there already emerges from this a stronger feeling for character. This is already the authentic though it is not the complete Cézanne.

VI

Behind Cézanne's head, in the picture just discussed, we see one of the landscapes of the period. *Les Toits rouges* and *Les Quais,* both in the Pellerin Collection, are typical examples. We find here the same dramatic emphasis, the same exuberance and vehemence in the drawing and in the abrupt oppositions of tone. Again black dominates, and dull red and brown ochres create a sad and impressive harmony. There is always the same defiant handling, the same determination to crush the spectator by the vehemence of the imaginative attack and to impose upon him at once the artist's own emotional attitude. In the *Toits rouges* the mood is one of melancholy and brooding, and the summary treatment, the almost melodramatic unreality of the scene is in harmony with a sombre, poetical mood. But in the *Quais* (Fig. 9) this romanticism is combined with a more realistic treatment. All is based on the actual scene. These barrels and warehouses, though summarily expressed, are evidently studied from nature and executed with a certain literalness. If ever the art of Cézanne could be considered to have touched that of his friend Zola it is at such a moment where an essentially romantic emotion is conveyed through a literal statement of commonplace matters of fact. But even here the likeness is of the slightest— even here Cézanne is far more an artist, less rhetorical, and less merely literal than his friend. In any case Cézanne's genius was destined to lead him ever further and further, even from this position where a comparison is not altogether absurd.

VII

Yet another group of pictures exists which is comparable with those we have studied. Like all the work of this period, they are marked by the same extravagances of invention and expression, by the same strange and disquieting mood. In these he is frankly and deliberately poetical. More than ever we see how the great "*poesie*" of Titian and his followers haunt his mind and inspire the attempt to vie with them. And in this group it is the Bacchanalian, lyric mode that he attempts. As ever he wishes to create afresh in the idiom of his day. Manet had shown the way: he had made the discovery that a Bacchanal is a picnic. And such in effect is the theme of a good many of Cézanne's poetical inventions, such as those illustrated in Fig. 10 and Fig. 11. In these he endeavours to cast over a scene of contemporary life the glamour of an idyllic mood. But how strangely gloomy and menacing this lyrical intention becomes in his hands—what funereal festivities do these Tintorettesque nudes celebrate in these sombre glades, in company with what preposterous ladies clothed in distorted caricatures of contemporary fashionable dress, with what obese and bald-headed bourgeois gentlemen! And what strange sequence of ideas led him to this disquieting incongruity between his pretext, his personages, and his setting? In most of these Bacchanals and "*poesie*" we find him emulating the composition of the great Baroque masters, but it is curious to note one rather slight work, a *Judgment of Paris* (reproduced in Vollard's *Cézanne*, Pl. 2), and dating from his earliest years, in which a simple, essentially classic design is adopted. It seems—as is so often the case in an artist's earliest work—to foretell the type of his maturer style. The figures here are placed on the same plane and grouped according to an almost primitive polarity.

But, apart from this, the works of a similar poetical inspiration of this period show him seeking to rival the sweep and amplitude

23

of Baroque rhythms and the richness of colour of the great Venetians without following them too closely in their mythological motives. He seeks the equivalent of those inventions in the landscapes of his own country and the life of his own time. But the familiar forms undergo an extraordinary deformation under the stress of this grandiloquent rhythm.

Everything at this period shows how intensely Cézanne was preoccupied by questions of style, how deeply he was influenced by the works which he studied in the Louvre. And from the first, as we have seen, he was observant of Dutch art. Whilst his romanticism and his love of whatever was impressive and exuberant led him to the Venetians and Rubens, his profound painter's instinct, his love of expressive *matière,* attracted him also to the more objective art of Holland. An evidence of this is the curious picture of *Two Men Playing Cards* (one is said to be Zola) (Fig. 12). Here the reminiscence of Pieter de Hoogh seems unmistakable. There is here no deliberate poetic intention, though as in all the works of this time the exuberance of his feeling, the vehemence of his emphasis, and the spirited handling communicate the same disquieting and hallucinatory mood as we derive from his funereal picnics. And as in these the colour scheme has the same bare simplicity. Once more upon the basis of black and white greys, the heavy reds, the celadon greens and pale blues detach themselves with an aggressive sonority. The picture proves how completely the ardent and restless romanticism of Cézanne's temper outweighs the visual data of any actual scene.

Throughout this period, then, Cézanne is dominated by the idea of the "Museum picture." The attainment of style is his great concern. But his sincerity and, let us add, his naïveté, are so great that he prefers to fall into extravagance, and risk the ridiculous rather than to achieve the empty success of pastiche. His very awkwardness here comes to his aid. He manipulates so clumsily the rhetorical and emphatic features of the great Baroque mas-

ters. He has not even the careless impetus of a Tintoretto, far less the innate mastery and ease of a Rubens. Daumier, to whom in these works he sometimes seems to approach, far surpassed him in the understanding of movement and in subtlety of rhythm.

But in all these efforts to rival the triumphant constructions of the Baroque, Cézanne was betrayed, even more than by his defective apparatus, by his instinctive, though as yet unconscious, bias towards severe architectural disposition and an almost hieratic austerity of line. We have already seen evidence of this in his earliest work, in the Byzantinism of the portrait of *l'Emperaire* and in the *Judgment of Paris,* and we shall have abundant evidence later on that, when once Cézanne had ceased to strive against the profounder conformations of his temperament, he accepted as the basis of his compositions an approach to the subject the very opposite of that which he sought for in the works we have been considering. If one compares the *Cardplayers* (Fig. 36) and the *Lazarus* (Fig. 1) one sees how much in the course of his evolution Cézanne was led to change his manner of envisaging the subject. And a similar change can be seen in the landscapes. In the end we find every person and every object presented to the eye in the simplest, most primitive fashion; instead of searching for diagonal perspective vistas, movements which cross and entwine, he accepts planes parallel to the picture-surface, and attains to the depth of his pictorial space by other and quite original methods. In the plenitude of his development Cézanne may be rightly thought of as rediscovering the tradition of Poussin; before those earlier inventions the name of Poussin would never come to mind—we think, perhaps, of Tintoretto and Rubens or of Delacroix and Daumier, never of the founder of French landscape.

But in insisting, thus, on the inequalities and imperfections of the works of this period, in exposing the internal contradictions which he was destined to resolve later on, we must not underestimate the great qualities which are already discernible in these

efforts. More happily endowed and more integral personalities have been able to express themselves harmoniously from the very first. But such rich, complex and conflicting natures as Cézanne's require a long period of fermentation. Cézanne could not create masterpieces whilst he persisted in struggling against the current of his genius, whilst diverse influences and ambitions waged war within him; but even in the least successful of these works he showed the authenticity of his inspirations and the exigence of his artistic conscience. We have to recognize his heroic, his almost contemptuous candour, and the desperate sincerity of his work. We cannot for a moment suspect him of wishing to impose on us an image which was not his own. The most fantastic personages, the most incongruous *mises en scène* always represent a reality which he is seeking to realize and express. Even under the exacting conditions posed for him on the one hand by his insatiable ambition to rival the masterpieces of the seventeenth century, to be grandiose and impressive, and on the other by his want of verisimilitude, he never covers himself by a trick. He would rather appear absurd than show a want of loyalty to his art. Everything is frank to a fault, and audaciously honest.

The public expects a little more regard than this. It is shocked by such inconsiderate manners. Clever and contriving artists may indeed flout the public, but the very insults must be in essence only a more subtle kind of flattery. Before canvases which reveal so total an indifference to its expectations as these it is implacable, and one can see why Cézanne's works whenever they were exhibited achieved a derisive and humiliating failure. This was, however, the greatest service which the public could have rendered to Cézanne at this stage. A success which had encouraged him to persist in this direction might have deprived us of the greatest master of modern times. Excessively sensitive to criticism, as we have seen that he was, he must have suffered much from this want of comprehension. And in spite of his bra-

vado, in spite of all his sallies against official art, he may well have felt less sure of himself than he appeared to be. And that not without cause. He had not really found himself. If he tried to read in the reactions of the spectators what he ought to become, what in essence he already was, he must have recognized that he had to renounce the attempt to be a visionary painter, to create from the data of his inner vision those grandiose compositions which had hitherto absorbed so much of his energy.

VIII

It is generally in small works thrown off by the way that an artist reveals the underlying trend of his nature, precisely because such works are less moulded by deliberate and conscious purpose. In them the profounder and more unconscious needs have full play. It is from this point of view that a certain interest attaches to the small *Sketch of Two Men* (Fig. 13). The colour is here of importance. Black still plays a large part, in the tall hats and clothes of the men. The tree has still the heavy dark tones of this period, but in the landscape viridians, cadmium greens and oranges appear, and these announce a new orientation towards a richer, more varied, more modulated harmony, one less reminiscent of "museum pictures," one more influenced by a direct outlook on nature. One feels here the evidence of a more curious observation, a more alert vision. Cézanne appears less wilful; he is working under a less feverish inner tension. This relaxation, this passive attention to external vision, though we find evidence of such a state in his earliest studies, is new at this period.

One might almost express this situation by saying that Cézanne shows here a new humility. It is a phenomenon of the greatest importance, because all artists of the highest order have to pass through this state. A Veronese or a Frans Hals may dispense with

27

humility. Their virtuosity is sufficient for their spiritual needs. But every artist who is destined to arrive at the profounder truths, a Rembrandt, a Velasquez, or a Daumier, requires an exceptional humility.

How much this acquisition cost Cézanne one may guess from the descriptions of his old age, from his suspicious, defiant misanthropy. Or we may gauge it by comparing two incidents in his life. In 1866, soon after his arrival in Paris and the immense scandal caused by Manet's *Déjeuner sur l'herbe,* he sent two pictures to the Salon, *La Femme à la puce* and *L'Après-midi à Naples.** The handling and composition of the latter picture was calculated to outrage official sensibilities even more than the title of the former. Both were from the point of view of the official Salon wilful outrages of good feeling. Naturally they were both refused, whereupon Cézanne addressed a letter to the State Superintendent of Fine Arts. The letter remained unanswered, and he again addressed the authorities. In this letter he says, "I must repeat to you that I cannot accept the illegitimate judgment of confrères whom I have not appointed to judge me. . . . Let the *Salon des Refusés* be re-established. Even if I should be the only artist in it, I ardently wish that the public should understand that I have no more wish to be confounded with the gentlemen of the jury than they appear to have to be confounded with me." It is needless to say that this letter also remained unanswered: it was filed with the marginal note by an official at the office, "Impossibility of re-establishing the *Salon des Refusés* for reasons of public policy," but it fortunately has been disinterred from the official files to show the sublime arrogance and self-confidence of the youthful Cézanne, to show how long and hard a fight he was destined to

*In Fig. 14, a reproduction is given of this composition, one of the most disconcerting of all the inventions of this period. It is, however, one of the most fascinating and also the most original. It comes nearer to success along the lines of Baroque design than any of the others. I believe the picture itself is lost.

wage. First of all a hopeless fight against official prejudice, and then the fight with the exuberant romanticism of his temperament, which he won so triumphantly.

The second anecdote of Cézanne's life which affords so vivid a contrast with the one above is that when, after a lifetime of solitude and neglect, he heard that M. Vollard had organized at his shop in the rue Lafitte what was really the first exhibition of his works that had ever been held, he and his son went furtively to visit it, and that, as they came away, he said to him, "And to think that they are all framed!" Not that Cézanne ever doubted the authenticity, even the supremacy of his genius; but he had learned, what was repugnant to his youthful exuberance, that his was a genius that could only attain its true development through the complete suppression of his subjective impulses, and that, slow to arrive at expression, it would be even slower to gain access to the minds of his fellow men. He had learned thoroughly the lesson of humility, and nothing is more touching, in the effect of his great masterpieces, than the intense humility which they evince by their utter denial of bravura or self-consciousness.

We find him then at this stage—about 1870, that is—waking gradually from his youthful dream of taking the world by storm as the acknowledged master of a grandiose romantic art, a creator of impressive and imposing imagery. We find him beginning at last to take advantage of his real gift, the extraordinary sensibility of his reaction to actual vision of no matter what phenomenon. We are at the beginning of the period of his great still-life pieces. If one looks at one of the few early still-lifes, such as the little canvas which figures in the portrait of his father and compares it with the later ones, the contrast is striking. The early ones, for all their qualities of brave handling and vigorous emphasis, are utterly superficial as compared with the intensive and penetrating interpretation of the later.

But here we are anticipating a little the history of his develop-

ment. We must return to consider Cézanne's relation with the Impressionists.

IX

From the very outset of his career in Paris Cézanne had been more or less in touch with the group of artists who were afterwards to be labelled as Impressionists. Already in 1863, M. Vollard tells us—and he probably had the information from Cézanne himself—Bazille came to Renoir's studio bringing, he declared, two "famous recruits." These were Cézanne and Pissarro. What is strange here is to find Cézanne already in touch with Bazille, because Bazille was precisely the one artist of the day whose expression is most in sympathy with Cézanne's. When one looks at the pictures which he executed just before the immense promise of his life was cut off by the war of 1870, in which he perished, one can hardly help finding in them an anticipation of Cézanne's later work. He alone of the Impressionists had from the first that sense of ordered architectural design which for the most part is conspicuously lacking in the artists of the group. Probably Cézanne, though alert enough to recognize from the first that these were the only vital painters of his day, was not yet ready to learn much from them. His vision and understanding were still obscured by his romantic exaltations; he had not digested the intoxication which the sight of the great Baroque designers produced in him. He was not ready yet to content himself with so sober, so deliberate, so comparatively unambitious a manner as Bazille's. And then Bazille died, and it was too late to learn from him. And meanwhile the Impressionist doctrine had developed in a new direction. The earlier Impressionists had not really departed from what one may call the central channel of pictorial tradition. They had taken up Impressionism at the point where it was left by the great masters of the seventeenth century,

by Rembrandt and Velasquez. Manet definitely associated himself with Velasquez and Bazille, though his colour effects are more strictly accepted from the actual vision, composed and painted in no startlingly new manner. What appeared shocking and new to the official eye was merely a return to the frank handling and detached, alert vision of painters like Velasquez. But with the prolonged study of open-air effects and the investigation of atmospheric colour a new phase set in. This was largely initiated by the researches of Monet. And here there really was a surprising novelty in the kind of visual phenomena which the artist was prepared to accept and in the methods of interpreting them in pigment.

Probably if we could view the whole of this movement from a historic distance we should see this specifically Impressionist movement as an excursus; it would appear as a loop in the curve of pictorial tradition—a somewhat similar loop to that which has been described in our own day by the Cubist movement. This loop would be seen to have had important reactions on the main curve, but to have returned again into it. It would be seen to have brought back certain valuable material into the main current, but to have abandoned a great deal of what at the time seemed of great importance to its exponents.

At all events by the year 1873, when circumstances brought Cézanne into closer contact with certain Impressionist painters, it was no longer a question of the comparatively assimilable Impressionism of the early Manet and of Bazille, but of the fully developed *plein air* doctrine, with its divisionism or method of breaking up the colour of a mass by means of small touches of comparatively pure colour.

The years 1873 and 1874 were of crucial importance then for the development of Cézanne's artistic personality. He spent the summers of those years at Auvers-sur-Oise, where he found himself in a colony of devotees of the new doctrine. The central fig-

ure of the group was the extraordinary one of Dr. Gachet, with his sable skin clasped round his throat, his immense top boots and his naval officer's peaked cap. He was an original; he was given over to philanthropic doctoring and a passionate devotion to whatever was new and surprising in art. He comes into art history once more, later on, by reason of the devoted care he lavished on Van Gogh during the last phase of his illness. But we find him already, in 1873, surrounded by the "advanced" artists, and to him belongs the singular honour of having been Cézanne's first patron.

But by far the most important of the group as far as Cézanne is concerned was Pissarro, with whom he at once felt himself in sympathy. Now for the first time he was in a mood to profit by contact with an older man, to put by for the time being his soaring ambitions. Up to now he had hardly ever contemplated the vision of actual life with a passive and indulgent eye. He had watched nature rather in order to find the readiest means for eternalizing the results of his inner fermentation of spirit and embodying his grandiose and bewildering dreams. But we have noted that with even this superficial gaze he had always instinctively known how to seize on those indications which were essential to the apprehension of the main volumes. If he was to pass through the discipline of the new Impressionism he was already provided with the best possible preparation, with the best preservative against its dangers. This summary construction of the main volumes which we noted in his previous works was solid enough to allow of the modifications and subtleties of Impressionist observation without leading to that disintegration of structure which was its lurking menace. And we noted, too, that in strict colour harmony Cézanne was never at fault. And if hitherto he had nearly always confined himself to a vigorously synthetic and arbitrarily simplified scheme, he was so much the

more fit to accept that enrichment and complication of the palette which the Impressionist vision inspired.

At Auvers Cézanne became in effect apprentice to Pissarro, who was already master of his method and in full possession of his personal style. It was, one may say, his first and his only apprenticeship. The teaching of the schools had never bitten on his rebellious temperament or beguiled his penetrating judgment. As we have seen, he had undergone already many influences, Courbet, Delacroix, not to speak of the Venetians and Rubens, whose pictures he had studied and copied in his long hours at the Louvre. But these masters were not present in the flesh. He had to guess at their methods. He lacked those detailed directions which one can only get from actual intercourse. In consequence Cézanne had, properly speaking, no method. He improvised all the time, and always with a rather desperate courage. One sees portraits executed in a clayey paste, ploughed up with the furrows of a large brush, others plastered on with vigorous applications of the palette knife, and, at least once in the *Banquet,* something like an anticipation of later methods, successive layers of a loaded brush imposed with a boldness that scorned precautions in its impatience to realize the imagined end.

But here at Auvers Pissarro put into his hands a technical method in which all was calculated beforehand, in which one proceeded with methodical deliberation and strict precaution, step by step, touch by touch, towards a preconceived and clearly envisaged goal.

This teaching by a master who was so evidently patient, humble and yet absolutely convinced of the efficacy of his method, gave a check to the defiant assurance of Cézanne. Pissarro's example cooled the Provençal impetuosity of his younger friend, and gave a new direction to his spirit. It turned him away from the inner vision and showed him the marvellous territory of external vi-

sion, a country which invited his adventurous spirit to set out on the discovery of new experiences.

It is true that the inner vision and the ambition to create *a priori* constructions corresponding to the demands of his subjective imaginative life never ceased to haunt him, but from this moment the "motive," the idea accepted from the visible world, claimed an ever greater proportion of his indefatigable energy.

The picture of *Auvers* (Fig. 15), painted in these years, is of capital importance in this context. It shows a turn of a road bordered on the left by a clump of trees, behind which a brighter light falls on the road. In the middle the view embraces the houses of the village, with their gardens sloping towards the stream, and a few interspersed conifers. It is as literal and prosaic an ensemble as one could find, and it is stated with scrupulous exactitude. But what is so remarkable—and what, alas, can hardly be guessed at from the reproduction—is that it is executed so entirely in Pissarro's Impressionist manner as to be almost mistakable for a picture by him.

But though superficially so similar, the difference is essential. Cézanne may make himself a humble and devoted observer of nature, may be obedient to Impressionist doctrine, he remains, none the less, more self-determined, more affirmative, more convinced than his master. One may indeed say that this is one of the finest pictures of a purely Impressionist inspiration that exists, precisely because one divines a more intense passion asserting itself through all its carefully pondered and sedulously executed statements.

The marvellous nicety of Cézanne's colour sense prevails above all. He was evidently excited, liberated and enriched by what the Impressionist vision revealed to him in nature, and, instead of losing his way in the infinitude of atmospheric colour, as so many weaker natures have done, he seems to have known from the

34

first how to dominate its complexity and render it organic. The too summary synthesis of his earlier colour is here completely abandoned, and he enters into all the complexities which nature, seen from this angle, reveals. The smallest face of stone wall becomes, for his analytic and searching gaze, of unspeakable richness. Its grey is composed of tints that tend now towards violet, now towards blue or blue-green, with hints here and there of citron yellows and oranges. And yet all remains solidly in its plane. The recession is everywhere strictly posed, and, over all, the atmosphere plays with its subtle, modifying influence. The tonality is so just throughout that the weft of the picture is perfectly continuous, and though all is distinctly affirmed the accents never interrupt it.

This picture, then, marks a moment of crucial significance for Cézanne's art, but we must remember that it was only a moment. The revelation of Impressionism was decisive and complete. Cézanne never went back on it. But it was not sufficient. He might follow Pissarro for one or two summers, but not longer. There was too much fervour in Cézanne's nature for him to be satisfied with what the strict Impressionist doctrine could give. He had too many things to bring out of his imagination, things of which Impressionism was innocent. He readily admitted that it was worth while thus to analyse patiently and completely the weft of colour sensations which nature spreads for the practised eye, but his imagination went beyond and behind that, towards profounder and less evident realities. He saw always, however dimly, behind this veil an architecture and a logic which appealed to his most intimate feelings. Reality, no doubt, lay always behind this veil of colour, but it was different, more solid, more dense, in closer relation to the needs of the spirit.

For at bottom this strange man, who seemed in life to be of an exasperating innocence, this man who read nothing but the

35

Catholic daily paper, trusted always to the Pope* for direction, and believed all the reassuring plausibilities of the social and intellectual reaction, had none the less a great intellect where his one passion was concerned, in whatever affected his art. He was, in short, too much of an intellectual in that respect to remain satisfied with pure Impressionism. In that he found a valuable method and an unexpected inspiration of the highest importance for his art, but he passed beyond it, and from this moment begins the thrilling drama of this determined explorer, who could not be turned from his purpose by the contempt of the world, the insults of the public, and the utter isolation in which he had to take refuge. Disillusioned and discouraged no doubt he became. The author of those high-spirited letters to the Ministry of Fine Arts, of those celebrated gibes at the official clique of the Salon, no longer had the heart to trouble them with any sign of his existence. He faded out so completely from the general artistic consciousness of his day that the present writer, when he was an art student in Paris in the 'nineties—a very ignorant and helpless, but still an inquisitive student—never once heard the name of the recluse of Aix. But for all this, though he had abandoned the struggle with the world and veiled himself in unbroken silence, he never doubted about his aim; his way was clear, he had to "realize," according to his own favourite expression. He gave himself up entirely to this desperate search for the reality hidden beneath the veil of appearance, this reality which he had to draw forth and render apparent. And it is precisely this which gives to all his utterances in form their tremendous, almost prophetic, significance.

* *'Moi qui suis faible dans la vie, je m'appuie sur ma soeur, qui s'appuie sur son confesseur, un jésuite (ces gens-là sont très forts), qui s'appuie sur Rome.'* Quoted by M. Vollard, "Paul Cézanne."

X

One may take as typical works of the period we are about to consider—a period which extends to beyond the middle of the 'eighties—a series of still-lifes. Before certain portraits and landscapes of Cézanne's maturity, before so impressive a masterpiece of genre painting as the *Cardplayers,* it would sound blasphemous to speak of our artist as a painter of still-life pictures, but none the less it is noteworthy that he is distinguished among artists of the highest rank by the fact that he devoted so large a part of his time to this class of picture, that he achieved in still-life the expression of the most exalted feelings and the deepest intuitions of his nature. Rembrandt alone, and that only in the rarest examples, or in accessories, can be compared to him in this respect. For one cannot deny that Cézanne gave a new character to his still-lifes. Nothing else but still-life allowed him sufficient calm and leisure, and admitted all the delays which were necessary to him for plumbing the depths of his idea. But there, before the still-life, put together not with too ephemeral flowers, but with onions, apples, or other robust and long-enduring fruits, he could pursue till it was exhausted his probing analysis of the chromatic whole. But through the bewildering labyrinth of this analysis he held always, like Ariadne's thread, the notion that changes of colour correspond to movements of planes. He sought always to trace this correspondence throughout all the diverse modifications which changes of local colour introduced into the observed resultant.

No doubt this idea of colour as revealing plasticity was far from new. Leonardo da Vinci had not only noticed the diverse colouring of the diversely orientated planes of an object, he had even given the scientific explanation. The Impressionist picture existed already, if not on canvas, at least in his writings. But for the most

part artists gave but casual attention to these phenomena, and certainly preferred other methods of suggesting to the eye the plasticity of objects. So that to the majority even of picture-lovers the truths which the Impressionists stated appeared to be insane paradoxes. By the true Impressionists, by men like Cézanne's companions at Auvers, Guillaumin and Pissarro, those changes of colour which correspond to movements of planes were vigorously expressed, but they were more concerned to seize the full complexity of the coloured mosaic of vision than to isolate and emphasize those indications in the total complex which are evocative of plastic form. They sought to weave across their canvas the unbroken weft of colour which their eyes had learned to perceive in nature. But this aim could not altogether satisfy such a nature as Cézanne's. The intellect is bound to seek for articulations. In order to handle nature's continuity it has to be conceived as discontinuous; without organization, without articulation the intellect gets no leverage. And with Cézanne the intellect—or, to be more exact, the intellectual part of his sensual reactions—claimed its full rights.

From this point of view we may regard the history of art as a perpetual attempt at reconciling the claims of the understanding with the appearances of nature as revealed to the eye at each successive period. Each new discovery in the world of visual experience tends to invalidate the constructions which had proved adequate theretofore, and the spirit is bound to reconstruct its shelter, taking into account the new data. This was notably the case with the new data supplied by the Impressionist discipline of the eye. Some artists were so enamoured of these new visual truths that it was sufficient for them merely to state and restate them in all their complexity. Monet's *Haystacks* and *Water-lilies* are there to prove it. But the greater spirits in this group sought from the very first to draw from these experiences the basis for new constructions. With Cézanne this need proclaimed itself as

38

more urgent and imperious than with Renoir and Degas themselves. Scarcely had he grasped the principles of Impressionism before he set himself to utilize them for further ends. And it is perhaps most evidently in this series of still-lifes that he arrived at a synthesis based on the new analysis of atmospheric colour.

Those critics who like to speculate and generalize must often regret that the genre of still-life has been so rarely cultivated throughout the course of European art, so much less, in fact, than was the case in China. Because it is in the still-life that we frequently catch the purest self-revelation of the artist. In any other subject humanity intervenes. It is almost impossible that other men should not influence the artist by their prejudices and partizanship. If the artist rebels against these, the act of rebellion is itself a deformation of his idea. If he disregards them and frees himself from all the commonplaces of sentiment, the effort still leaves its traces on his design. But the still-life excludes all these questions and guards the picture itself from the misconstructions of those whose contact with art is confined to its effect as representation. In still-life the ideas and emotions associated with the objects represented are, for the most part, so utterly commonplace and insignificant that neither artist nor spectator need consider them. It is this fact that makes the still-life so valuable to the critic as a gauge of the artist's personality. How many obscure points in Raphael's artistic psychology might be cleared up if we had a series of still-lifes by him. How fascinating to see what Castagno or Piero della Francesca would have accomplished. One can almost guess at the superb revelations of painter's quality which Luca Signorelli would have supplied.

There are, of course, exceptions to this purely plastic significance of still-life. The symbolist, by a careful choice of objects and by arranging for them a special pictorial context, can force them to reveal some entirely non-plastic emotion. There are also rare cases where an artist has so intensely dramatic a manner that

by a special emphasis he can give, even to the still-life, a kind of dramatic significance. Goya, for instance, once painted a plucked fowl in such a way as to suggest an atrocious tragedy, to make it a companion piece to one of his *"Desastros de la guerra."*

Cézanne at one time might well have had similar aims, but by the period which we are considering he had definitely abandoned them. He eagerly accepts the most ordinary situations, the arrangements of objects which result from everyday life. But though he had no dramatic purpose, though it would be absurd to speak of the drama of his fruit dishes, his baskets of vegetables, his apples spilt upon the kitchen table, none the less these scenes in his hands leave upon us the impression of grave events. If the words tragic, menacing, noble or lyrical seem out of place before Cézanne's still-lifes, one feels none the less that the emotions they arouse are curiously analogous to these states of mind. It is not from lack of emotion that these pictures are not dramatic, lyric, etc., but rather by reason of a process of elimination and concentration. They are, so to speak, dramas deprived of all dramatic incident. One may wonder whether painting has ever aroused graver, more powerful, more massive emotions than those to which we are compelled by some of Cézanne's masterpieces in this genre.

We may take as typical of this series and as one of the most completely achieved, the celebrated still-life of the *Compotier* (Fig. 16). It dates, no doubt, from well on into the period under consideration, from a time when Cézanne had completely established his personal method. The sensual energy which had led him from early days to knead a dense paste into shape upon his canvas persists still. But his method of handling it has become far more circumspect. Instead of those brave swashing strokes of the brush or palette knife, we find him here proceeding by the accumulation of small touches of a full brush. These small touches had become a necessity from the moment he undertook the care-

ful analysis of coloured surfaces. To the immediate and pre-conceived synthesis which in the past he had imposed upon appearances, there now succeeds a long research for an ultimate synthesis which unveils itself little by little from the contemplation of the things seen. Not that he fumbles: each touch is laid with deliberate frankness, as a challenge to nature, as it were, and, from time to time, he confirms the conviction which he has won by a fierce accent, an almost brutal contour, which as often as not he will overlay later on, under stress of fresh discoveries and yet again reaffirm. These successive attacks on the final position leave their traces in the substance of the pigment, which becomes of an extreme richness and density. The paste under his hands grows to the quality of a sort of lacquer, saturated with colour and of an almost vitreous hardness.

So perfect a correspondence of material quality to the idea as this picture shows is by no means of common occurrence in art. It is not always possible for the artist to find in the material to his hand the perfect embodiment of his feeling. One might almost say that it is only at certain moments in the history of art or in the career of a particular artist that everything concurs to produce it. Often indeed we may have to divine the idea through a material quality which opposes a certain opacity. At other moments the matter itself becomes eloquent. Thus, to take a few random examples, the refined and spiritualized sensuality of a Fra Angelico finds a perfect response in the opalescent washes of egg-tempera, but the same technique refuses to bear out fully the plastic gravity of a Masaccio, and one can see at once how much happier Signorelli would have been had he dared to venture on the generous impasto of modern oil painting.

There is no pictorial issue about which the public is so exacting as that of material quality. It has its strong preferences which it can sometimes impose on the artist. It is thus that the licked and polished surfaces of a Dou and a Van der Werff were created

41

in response to a particularly unenlightened connoisseurship, and, in general, the Dutch painters were constrained to a fictitious appearance of finish and dared not use a more frankly expressive handling. It is this that renders Rembrandt's case so extraordinary. Because it was Rembrandt, in his later years, who revealed the full expressive possibilities of matter. With him nothing is inert, the material is permeated and, as it were, polarized by the idea, so that every particle becomes resonant. Chardin's tenderer, more fragile sensuality finds its expression in a totally different quality, but here again the response is complete, though perhaps less unfailingly so. There are, that is, inequalities in his work; there are places where the activity of the spirit seems to fail and to leave passages relatively inert, acting as mere foils or backgrounds to others.

It is by such considerations and comparisons that we may judge of the rare perfection of this work of Cézanne's. And one must, I think, venture to proclaim boldly that it represents one of the culminating points of material quality in painting. Under the double impulsion of his analysis of coloured surfaces and of his native feeling for large structural unities Cézanne created a new pictorial beauty. And from our comparison of this quality in the work of other painters we may conclude that he shows himself nearer to Rembrandt than to Chardin. If, on the one hand, his voluptuous feeling for colour reminds one of the seductive sweetness of Chardin, on the other hand for him, if possible more than for Rembrandt, there are no parts of the surface more or less expressive than others, for his sensibility is active throughout. There may be parts where the emphasis falls, but those things that one might consider insignificant are analysed with the same care and stated with the same conviction as those which play a leading part in the composition.

This question of material quality depends, of course, to a great extent on the artist's "handwriting," on the habitual curves which

his brush strokes describe. In his earlier works, as we have seen, Cézanne affected an almost florid and exuberant curvature modelled upon that of the Baroque painters, but, one has to admit, without ever attaining to their elegant incontinence. It was, one may suspect, the expression rather of his willed ambition than of his fundamental sensibility to form. Under Pissarro's influence he holds himself in. The new conception of external vision which he was practising evidently absorbed his attention, and he became of necessity far less conscious of his handling. He had, as it were, to leave his hand to manage, as best it could, to convey the ideas he was intent upon. His gestures, in consequence, were more restrained. In this still-life the handling has recovered something of its older spirit, but it remains far more restrained and austere. He has adopted what we may regard as his own peculiar and personal method. He has abandoned altogether the sweep of a broad brush, and builds up his masses by a succession of hatched strokes with a small brush. These strokes are strictly parallel, almost entirely rectilinear, and slant from right to left as they descend. And this direction of the brush strokes is carried through without regard to the contours of objects. This is the exact opposite of Baroque handling. In Rubens, for instance, what strikes us is the vertiginous rapidity and dexterity with which his hand adapted itself to the curved contours of his forms. The grave, methodical but never lifeless handling of Cézanne's *Compotier* is the exact antithesis to that.

The public, which is more attracted in a picture by virtuosity and brilliance than by any other quality, was violently repelled by the broken surfaces of the Impressionists. But in those exhibitions in the 'seventies—notably that of 1877—where Cézanne appeared as one of their group, it was always against Cézanne that the most violent insults were hurled. His handling seemed not only clumsy and ugly to the last degree, but actually to be a calculated outrage of the spectator's feelings. Nor did this preju-

dice disappear quickly. In the dispute over the legacy of the Caillebotte Collection to the Luxembourg the State, while grudgingly willing to accept the other Impressionist pictures, for a long tine insisted on the exclusion of Cézanne's works on the ground that they could never be exposed in a public gallery. An echo of the same violent reaction was heard in England as lately as in 1910, when, at the Grafton Gallery Exhibition, Cézanne was first seen effectively in this country. It was found then that what were regarded as the monstrosities of later artists like Matisse and Picasso, were more easily to be condoned than the classic austerity of Cézanne's handling. "Butcher" and "bungler" were comparatively mild terms in the vocabulary of abuse employed by some well-known critics who have long since recognized how far their first reactions were at fault.

Even those few critics who ventured to champion Cézanne's work towards the end of the last century felt it necessary to adopt an apologetic tone about the so-called clumsiness and awkwardness of his handling. This attitude of the public, strange and unintelligible as it seems to us now, is not in the least to be wondered at. Artists only—and only open-minded and indulgent artists— are capable of seeing at once through the medium of an unusual and therefore antipathetic "hand-writing" those qualities of plastic design which may have necessitated it. In no other pictorial quality is it so difficult to discount the effect of custom and fashion. Many pictures repel us at first sight which might charm us at once by their qualities of organization and design were they not obscured for us by an unfamiliar "hand-writing." Artists have even been led to believe in a quality of handling good in itself, forgetting that every sensibility has to discover its own appropriate expression in this respect. And by now this influence of fashion works in the other direction. Cézanne's handling is so universally accepted that we are tempted even to admire too much any picture which reminds one of it.

44

Hitherto we have considered this picture solely from the point of view of the surface it offers to the eye. It is true that this surface has already yielded us certain important facts about Cézanne's emotional reactions at this period. But we must also consider it from the more fundamental point of view of the organization of the forms and the ordering of the volumes. We have already guessed, behind the exuberances of Cézanne's Baroque designs, a constant tendency towards the most simple and logical relations. Here that simplicity becomes fully evident. One has the impression that each of these objects is infallibly in its place, and that its place was ordained for it from the beginning of all things, so majestically and serenely does it repose there. Such phrases are, of course, rather fantastic, but one has to make use of figurative expressions to render at all the extraordinary feeling of gravity and solemnity which the artist has found how to evoke from the presentment of these commonplace objects. One suspects a strange complicity between these objects, as though they insinuated mysterious meanings by the way they are extended on the plane of the table and occupy the imagined picture space. Each form seems to have a surprising amplitude, to permit of our apprehending it with an ease which surprises us, and yet they admit a free circulation in the surrounding space. It is above all the main directions given by the rectilinear lines of the napkin and the knife that make us feel so vividly this horizontal extension. And this horizontal supports the spherical volumes, which enforce, far more than real apples could, the sense of their density and mass.

One notes how few the forms are. How the sphere is repeated again and again in varied quantities. To this is added the rounded oblong shapes which are repeated in two very distinct quantities in the *Compotier* and the glass. If we add the continually repeated right lines and the frequently repeated but identical forms of the leaves on the wallpaper, we have exhausted this short cata-

logue. The variation of quantities of these forms is arranged to give points of clear predominence in the *Compotier* itself to the left, and the larger apples to the right centre. One divines, in fact, that the forms are held together by some strict harmonic principle almost like that of the canon in Greek architecture, and that it is this that gives its extraordinary repose and equilibrium to the whole design.

In the shapes by which he has defined the *Compotier* and the glass, Cézanne shows to what a point the urge of this harmonic sense controlled even his vision of the object. Apart from these two objects rectangular and spherical volumes predominate. That is to say, the forms are the most elementary possible. But the circles of the *Compotier* and glass seen in perspective give us ovals, and the oval is a form that evokes a different kind of sentiment altogether, as one can see by its disturbing effect in Gothic architecture. It harmonizes ill with the circle and the right line. So that one is not astonished to find that Cézanne has deformed them into oblongs with rounded ends. This deformation deprives the oval of its elegance and thinness and gives it the same character of gravity and amplitude that the spheres possess. One may note, by the by, that this deformation occurs constantly in early Chinese art, and doubtless at the dictates of the same instinctive feeling.

It is probable that Cézanne was himself ignorant of these deformations. I doubt if he deliberately calculated them; they came almost as an unconscious response to a need for the most evident formal harmony. We have seen many similar deformations since Cézanne's day, sometimes justified and sometimes mere responses to the demands of fashion, than which nothing more tiresome can be imagined. A deformation which is not an imaginative and harmonic necessity is only a piece of snobbish orthodoxy. The snobbists of the 'eighties were not likely to be tender to the "ill-drawn" *Compotier* of Cézanne.

The critic, I hold, should be loyal enough to his own impressions to confess to what is probably due to his own defects. I must admit therefore that there is one passage in this otherwise consummate design of which the meaning escapes me. I cannot see the necessity of the shadow cast by a half-opened drawer in the kitchen table. This vertical shadow troubles me. It seems to check the horizontal and slightly diagonal movements of the napkin-folds and to lessen their suavity. It is precisely because otherwise this composition seems to me of so rare a perfection and so rigorous an exactitude that it disturbs me always to feel a temptation to cover this part of the canvas with an indiscreet finger. It is an experiment that the reader can easily try on the reproduction, and at least settle the point for himself.

It is easy to see that with so strong a feeling for volumes and masses, with the desire to state them in shapes of the utmost precision, the contours of objects became almost an obsession to Cézanne. It is evident that for a painter who is mainly occupied in relations of planes those planes which are presented to the eye at a sharp angle, that is to say in strong foreshortening, are the cause of a certain anxiety. The last of this series of planes forms the contour, and is a plane reduced to a line. This poses a terrible question—the plane which has no extension on the surface of the canvas has yet to suggest its full extension in the picture-space. It is upon that that the complete recession, the rotundity and volume of the form depends. The very fact that this edge of the object often appears with exceptional clearness complicates matters by bringing the eye back, as it were, to the surface of the canvas.

For the decorative painter whose main object is the organization of his design upon the surface, this is no difficulty, rather an advantage; but for painters to whom the plastic construction is all-important it becomes serious. For them, the contour becomes at once a fascination and a dread. One can see this for Cézanne in

his drawings. He almost always repeats the contour with several parallel strokes as though to avoid any one too definite and arresting statement, to suggest that at this point there is a sequence of more and more foreshortened planes. He has to forego the quality of the linealist. The harmonious sweep of a contour which fascinates a Botticelli or an Ingres is not for him. And here again he shows his affinity with Rembrandt.

For the pure Impressionists this question of the contour was not so insistent. Preoccupied as they were by the continuity of the visual weft, contour had no special meaning for them; it was defined more or less—often vaguely—by the sum of indications of tone. But for Cézanne, with his intellectual vigour, his passion for lucid articulation and solid construction, it became an obsession. We find the traces of this throughout in this still-life. He actually draws the contour with his brush, generally in a bluish grey. Naturally the curvature of this line is sharply contrasted with his parallel hatchings, and arrests the eye too much. He then returns upon it incessantly by repeated hatchings which gradually heap up round the contour to a great thickness. The contour is continually being lost and then recovered again. The pertinacity and anxiety with which he thus seeks to conciliate the firmness of the contour and its recession from the eye is very remarkable. It naturally lends a certain heaviness, almost a clumsiness, to the effect; but it ends by giving to the forms that impressive solidity and weight which we have noticed. And indeed we have to admit that the conciliation is attained. At first sight the volumes and contours declare themselves boldly to the eye. They are of a surprising simplicity, and are clearly apprehended. But the more one looks the more they elude any precise definition. The apparent continuity of the contour is illusory, for it changes in quality throughout each particle of its length. There is no uniformity in the tracing of the smallest curve. By reason of these incessant affirmations and contradictions similar results follow from quite

different conditions. We thus get at once the notion of extreme simplicity in the general result and of infinite variety in every part. It is this infinitely changing quality of the very stuff of the painting which communicates so vivid a sense of life. In spite of the austerity of the forms, all is vibration and movement. Nothing is less schematic than these works, even when, as here, the general forms have an almost geometrical appearance.

I hope this tiresome analysis of a single picture may be pardoned on the ground that, if one would understand an artist, one must sooner or later come to grips with the actual material of his paintings, since it is there, and nowhere else, that he leaves the precise imprint of his spirit. Moreover, after so elaborate a study, we can pass some of his other still-lifes in rapid review.

The *Still-life with a Ginger Jar* (Fig. 17), which is also from the Pellerin Collection, is conceived in a very different vein. The extreme gravity of the *Compotier* is here replaced by a certain gaiety and lightness. The tone is comparatively light, and the colour, with its inter-play of violet-rose and bluish tints, is almost brilliant. The opposition, so constant with Cézanne, of grey blue and coppery grey is seen here in a heightened key throughout the background, and against this, the oranges, greens and reds of the fruit tell with glowing intensity and freshness. And in harmony with this mood the forms are almost agitated, and, what is very unusual with Cézanne, there are a number of small and nearly equal volumes with no very marked dominance at any point.

In the *Still-life with a Soup-tureen and Bottle* (Fig. 18) we find again an extreme economy in the forms, and great simplicity in the relation of volumes. The picture is painted with the utmost freedom and with less elaborate research for the contours which are here almost casual. But the volumes are splendidly assured, and the carelessness—relatively speaking—of the handling gives great purity to the vivid colours of this composition. The table-cloth is of a dark, rich vermilion, modified by bluish inflections

where the light falls on it from the window. The citron yellows of the apples and the vivid black of the bottle stand out forcibly on the roses and pale greens which compose the background. The colours here "sing" with a ravishing intensity and purity.

To give so large a space to the consideration of the still-life paintings of this period may seem to demand apology—but it is hard to exaggerate their importance in the expression of Cézanne's genius or the necessity of studying them for its comprehension, because it is in them that he appears to have established his principles of design and his theory of form. A certain phrase let fall by him in his old age has often been quoted. It is to the effect that natural forms all tend to the sphere, the cone, and the cylinder. Whether Cézanne regarded this as a discovery of objective truth, as something like a law of nature, one may doubt. Its real meaning for us at all events must rather be that in his endeavour to handle the infinite diversity of nature he found these forms convenient as a kind of intellectual scaffolding to which the actual form could be related and referred. At least it is very noticeable that his interpretation of natural form always seems to imply that he is at once thinking in terms of extremely simple geometrical forms, and allowing those to be infinitely and infinitesimally modified at each point by his visual sensations. This was, in fact, his solution of the artistic problem, which is always how to find some method of creating things which are at once amenable to human understanding, and have the concrete reality which, in every other experience, eludes our comprehension.

One notes at all events how constantly spherical forms absorb his attention. There is a whole series of still-lifes—most of which are little known—devoted to studies of skulls, sometimes a single skull, sometimes three or four together. It is needless to say that for Cézanne at this period a skull was merely a complicated variation upon the sphere. By this time he had definitely abjured all suggestion of poetical or dramatic allusion; he had arrived at

what was to be his most characteristic conception, namely, that the deepest emotions could only exude, like a perfume—it is his own image—from form considered in its pure essence and without reference to associated ideas. And not only do the still-lifes give us the clearest insight into his methods of interpreting form, they also help us to grasp those principles of composition which are characteristic of his work henceforth.

Thus in the *Still-life with a Cineraria* (Fig. 19) we find an intensely personal conception of composition and one that is utterly at variance with his earlier practice. It may be expressed by saying that it indicates a return to Poussin, a renunciation of Delacroix and his Baroque antecedents. Poussin pushed his intense feeling for balance so far that he habitually divided his compositions by a marked central line or gap—as it were a caesura in the line. And here we find Cézanne, probably quite unconsciously, doing the same thing, by placing the handle of the drawer, the dish of cherries, and the large pot one above the other on the centre line. We find him, too, accepting the utmost parallelism of the objects to the picture plane. Thus, in direct opposition to all Baroque ideas, with an almost exaggerated return to the most primitive practice, he arranges the table exactly in the middle and so as to be seen at right angles, parallel, that is, to the picture plane. Elsewhere we find strongly accented verticals. This extremely rigid architecture is only broken by the repeated diagonals of the canvas stretcher on the floor and the recession of the room to the left; this is balanced by the sharper diagonal of the ladle in the pot and the edge of the napkin as it falls over the table. This architectural rigour and this primitive simplicity in the angle of approach, reveals the essence of Cézanne's conception. Everything here reinforces the idea of gravity, density and resistance. In relation to this may be considered the phrase, reported by M. Joachim Gasquet: "Everything we see is dispersed and disappears. Nature is always the same, but nothing remains of it, nothing of what we

see. Our art should give to nature the thrill of continuance with the appearance of all its changes. It should enable us to feel nature as eternal."

The colour here, as always, is profoundly expressive of the same feeling. For all its purity and brilliance it, too, enforces the same pensive and solemn mood. Here the background is of a heavy grey modulated with coppery reds, against which blazes the intense emerald-green of the pot, the violent yellow-greens of the cineraria leaves, the vivid ochres of the table, and the whites of the napkin modelled with hatchings of blue and blue green. Finally a deep note of intense blue enamel in the milk can seems to culminate and control this deep and vivid harmony.

XI

To this period of Cézanne's life we owe many well-known works. The large and extremely studied portrait of M. Choquet dates from 1877—the same year as the *Compotier*. The smaller head of the same sitter (Fig. 20) cannot differ greatly in date. Like some other works of this period, when he was still, as it were, digesting the new visual material which Impressionism had offered him, there is evidence of incessant revision and continual repainting. And this has been carried on here until the whole surface is heavily loaded with pigment which acquires a crumbled, granular surface. It does not retain the beautiful transparent, enamel-like quality which we remarked in the *Compotier*. When this happens the colour loses something of its saturation and clarity, it becomes almost turbid and opaque. But for all the obstinate endeavour of which this shows signs the firm cohesion of design, and the vigorous modelling, show how completely he was able in the end to express his idea. And how marked in comparison with the almost brutal bravura of the earlier portraits is

52

the delicate sensitiveness expressed by these contours and this modelling.

The portrait of *Mme Cézanne* (Fig. 21) is far less laboured, and shows more easy mastery of the idea. It will be noted how near it comes to the *Compotier* in the firm simplification of the oval of the head, the rugged massiveness of the volumes, and the density and richness of the *matière*. It expresses, too, that characteristic feeling of Cézanne's—perhaps at its intensest at this period—of the monumental repose, the immense duration of the objects represented, a feeling which is conveyed to us by the passionate conviction of each affirmation. That passion, no doubt, was always present, but whereas in the earlier works it was hasty and overbearing, its force is all the greater for being thus held in and constrained.

Cézanne's *Self-portrait* (Fig. 47) belongs to a slightly later date, but is even more characteristic of this period. It is interesting at this point to look back upon the two other self-portraits which I have chosen from the considerable number which he did. As compared with the second portrait (Fig. 8) and still more with the first (Fig. 6) we note how much subtler and more penetrating is his interpretation of the forms here. How the bony structure of the skull reveals itself through subtle variations of the contour, and how much more objectively he gazes on himself. He poses to himself as he wished his sitters to pose, "as an apple," and he looks at his own head with precisely the same regard that he turned on an apple on the kitchen table. But with this renunciation of all *parti pris* how much more eloquent and vital is the presence revealed to us.

These three self-portraits form a most illuminating sequence. We see by what degrees Cézanne has descended from the fiery theatrical self-interpretation of his youth (Fig. 6) to this shrunken and timid middle-aged man. His eyes no longer flash out a men-

ace; he is no longer interested in what effect he may produce on others; all his energy is concentrated in that alert, investigating gaze.

This is one of the most elusively seductive colour harmonies of this period. The wallpaper behind the artist's head is of a dull golden olive-green broken by touches of blacker and colder green where it approaches the space to the left, which is an indescribable atmospheric bluish-grey broken with warmer hatchings, tending to orange. The dull greens are taken up again in the green-blue-browns in which the faded black of the coat is interpreted. Colder bluer greenish blacks in the beard lead to the blue-green whites of the shirt, and in the flesh vivid reds and oranges grading to purples and greens strike a vibrant chord which yet never breaks the tender delicacy and extreme sobriety of the total effect. That effect is not altogether unlike some of Titian's harmonies, only it is arrived at by the synthesis of an infinitely greater number of tints and gradations.

The nation is fortunate in possessing, thanks to the generosity of Mr. Courtauld, so typical an example of Cézanne's solution of the problem of colour. It is evident that all his life he was continually brooding over one tormenting question; how to conciliate the data of Impressionism with—what he regarded as an essential to style—a perfect structural organization. The atmosphere in which this picture is suffused, through which every local tone manifests itself, is indubitable; he has nicely estimated the grey-blue and violet notes which the skin of the skull receives as it recedes towards the background, every plane moves according to the newly apprehended optical principles, and yet there is no disintegration, the local colour holds its own, and the *object* has its complete reality. It is evident that this was one of Cézanne's incessant preoccupations. Difficult as he was about his contemporaries and grudging of praise, he was subjugated by the miracles of Monet's observation. "Monet," he used to say, "Monet is

only an eye, but, heavens, what an eye!" And yet he knew that this was not enough for him.

M. Emile Bernard quotes him as saying: "The whole of painting is there—to yield to the atmosphere or to resist it? To yield is to deny the 'localities,' to resist is to give them their force and variety. Titian and the Venetians worked by 'localities,' and that is what true colourists do." This suggests, however, that, for the moment, he had abandoned the attempted synthesis and renounced Impressionism, which certainly was not the case. It was this determination to arrive at a perfect synthesis of opposing principles, perhaps, that kept Cézanne's sensibility at such a high tension, that prevented him ever repeating himself, from ever executing a picture as a performance. Each canvas had to be a new investigation and a new solution.

XII

Among landscapes of this period we may take as typical the *Provençal Mas* (Fig. 22). The texture here is closely akin to that of the *Compotier.* As in that, the surface is wrought by successive layers of small hatched strokes of full pigment to a marvellous enamel-like density and dull, transparent richness. As in this, too, there is the same economy of forms, rectilinear shapes predominating almost exclusively. It shows, too, that vigorous logic in the sequence of the planes, which evolve in an unbroken succession throughout every part of the picture, enforcing irresistibly upon the spectator's imagination their exact recession at each point and enabling us to grasp the significance of all the interplay of their movements. In relation to this picture, so typical of certain fundamental qualities of Cézanne's nature, one is reminded of a phrase of his, uttered in answer to M. Vollard's saying that Rosa Bonheur—(of all people!)—seemed to him very powerful. "Yes, but it's so horribly 'like'" (*si horriblement ressem-*

blant). For we may note in this picture the complete lack of verisimilitude. There is here a total disregard of those convincing details of texture, those small specific characteristics which our everyday vision seizes on at once for the purposes of life.

We may describe the process by which such a picture is arrived at in some such way as this:—the actual objects presented to the artist's vision are first deprived of all those specific characters by which we ordinarily apprehend their concrete existence—they are reduced to pure elements of space and volume. In this abstract world these elements are perfectly co-ordinated and organized by the artist's sensual intelligence; they attain logical consistency. These abstractions are then brought back into the concrete world of real things, not by giving them back their specific peculiarities, but by expressing them in an incessantly varying and shifting texture. They retain their abstract intelligibility, their amenity to the human mind, and regain that reality of actual things which is absent from all abstractions.

Of course in laying all this out one is falsifying the actual processes of the artist's mind. In reality, the processes go on simultaneously and unconsciously—indeed the unconsciousness is essential to the nervous vitality of the texture. No doubt all great art arrives at some such solution of the apparently insoluble problem of artistic creation. Here in certain works of Cézanne we seem to get a particularly clear vision of the process of such creations.

To a rather later date we must ascribe the splendid landscape of *Gardanne* (Fig. 23). Cézanne worked there in 1885 and 1886. It has to a supreme degree that impressive pictorial architecture, that building up of sequences of planes which has a direct "musical" effect on the feelings. Much depends here on the subtle approach which is prepared for the culminating passages. The flatness and emptiness of the foreground, only broken by a railing or low wall—which is of crucial importance for directing

our imagined movements—the flat resistance of the *repoussoir* formed by the houses to the left, the inclination of the shed-roof in the near field—all these prepare us for the rapid and agitated criss-cross of planes by which the eye mounts to the arresting perpendicular of the house fronts on the summit and the final escape, as it were, which the converging uprights of the tower allow. This analysis only calls attention to the main relations of an extremely complex system in which prolonged contemplation will reveal innumerable minor confirmations of and variations on the theme. There are few landscapes so moving, few which show so total an indifference to the accidental and associated charms of the picturesque. Not of course, that even its bleakness and austerity is underlined for directly dramatic purposes.

At the beginning of this period—in 1877—Cézanne made another desperate and heroic attempt at the construction of one of those *"poesie"* which had so constantly attracted and tormented his spirit. It is the picture of the *Bathers* reproduced in Fig. 24. It has none of the impetuous rush of the earlier Baroque works. Cézanne does not rely here on the impetus of sweeping contours and violent movement. The design is based on rectangular directions, parallelograms and pyramids. And these forms are situated in the picture-space with that impressive definiteness, that imperturbable repose of which Cézanne had discovered the secret. One suspects, however, that an endless search was needed to discover exactly the significant position of each volume in the space—a research in which the figures have become ungainly and improbable. At any moment the demand of the total construction for some vehement assertion of a rectilinear direction may do violence to anatomy, or the difficulty of finding the exactly right position of a contour may lead to incessant repainting and an unheard-of accumulation of pigment, as has happened, for instance, in the crucially important contour of the great cumulus cloud to the right, and the building of the pyramidal remi-

niscence of Mt. Ste Victoire to the left. But the very desperation of the artist's sincerity has its effect on the mind, and I doubt if any picture of modern times has so nearly approached to the lyrical intensity of Giorgione's mood. I would not suggest here any direct hint at Giorgione's design, though I suspect Cézanne of always having entertained the ambition of creating a new *Fête champêtre* on modern lines.

Returning now to the landscape of this extremely prolific period. Belonging, I suspect, to a rather later date than those hitherto considered, is that reproduced in Fig. 25. We see by this that what I called the pictorial architecture of Cézanne is not dependent on the predominance of architectural objects in the scene, for here trees, hills, and the undulations of the terrain are used to build up an even more rectangular and severe construction. It is a fine example of Cézanne's power to handle a great number of quantities, to hold them here and there by slightly larger and more emphatic ones—note, for instance, the immense importance in this of the three tall pyramids in the left centre, and the value for emphasis of the gap of light seen between the trunk of one tree and the foliage of the next. And yet the perpetual slight movements of the surface, the vibrating intensity and shimmer of the colour—atmospheric without a hint of vagueness—gives to this austere design the thrill of life.

It will be convenient to carry on our study of the landscapes to an example, *Maisons au bord de la Marne* (Fig. 26), which belongs to the very end of our period, or even to the transition to the next. It dates from about 1886. The audacious simplicity and directness of Cézanne's approach to the "motive" surprises us by its complete and unexpected success. Nothing in the landscape of earlier art, unless indeed we go right back to the Primitives, where landscape is only subsidiary to other elements, would have authorized a painter to place himself thus before such an assemblage of forms. It seems a denial—though unconscious

and with no idea of defiance—of all the accepted ideas of landscape art. The point of view is taken from one side of a river—one looks across to the opposite bank, which is parallel to the picture plane. This grassy bank is almost uniform and featureless. Behind, a tree divides the composition in half with the rigid vertical of its trunk, above which its foliage forms an almost symmetrical pyramid, which is completed and amplified by the group of houses behind. Only to the right is there a very unaccentuated suggestion of a diagonal movement, letting us out into the distance. Nothing could be further removed from the Baroque, and even a Primitive would scarcely have accepted so elementary an arrangement. And yet there is nothing in the least naïve or "simplist" about this for all its simplicity. The Egyptian symmetry of this architectural plan is modified everywhere by an infinity of minute movements. There is no monotony, no repetition. Cézanne shows the extraordinary power of his sensibility to register and interpret slight modifications by his treatment of the river bank, which seems to offer no hold for formal design, and yet by the logical progression of minute variations of tone and colour he is able to pose it as a solid and effective element in the plastic construction. Even the symmetry is never quite so exact as it seems at first sight—the balance is always, as it were, menaced and redressed—it is a dynamic and not a static equilibrium. There is nothing wilful or demonstrative in the statement of these large, simple masses, above all no hint of the imposition of a schematic idea—the artist's sensibility keeps its full control. The simplicity is not preconceived; it is the last term of a process of interpretation of the infinity of nature. The colour is equally expressive in the inexhaustible variety of its inflections, and in a subtlety which defies analysis. The harmony allows of vigorous notes of orange, red and intense green without impairing the close-knit unity of the scheme, which gives an effect of silvery grey.

To this landscape of the Isle of France we may oppose Fig. 27,

where the bleak nakedness of a wintry landscape is forcibly expressed. Here the rectilinear structure and the preponderance of right angles is almost disconcerting at first, but we feel that Cézanne has accepted this bleakness of the scene with a sort of austere voluptuousness. The exaltation of the artist's mood, his passionate emotion, translate themselves everywhere in the rich elaboration of the pigment. These bare surfaces of grey wall give evidence of obstinate and patient research into all their variations of surface and colour. Again, it is by the accumulation of innumerable slight variations that he is able to construct for the imagination this immensity of space filled with light and vibrating with life.

To somewhere about the same period—towards the end of the 'eighties—we may assign the beautiful landscape now in the Tate (Fig. 28), with its expressive contrast of the agitated movements of the rocks and tress in the foreground with the suave convexities of the distant hill.

XIII

In the paintings of the later 'seventies and early 'eighties we find, then, that Cézanne had arrived at a consistent method. It is in the work of this period that his pigment attains to a peculiar density and resistance and an enamel or lacquer-like hardness and brilliance of surface. This is the result of his incessant repetitions and revisions of the form, particularly of the contours. But somewhere around 1885 a progressive change in his handling becomes apparent. The hatched strokes are more loosely spaced, the impasto becomes thinner, and has evidently been applied in a more liquid state. Cézanne seems to put off as long as possible the complete obliteration of the canvas, so that there are left small interstices of white here and there, even when the picture is finished. The actual handwriting of the brush strokes also becomes looser and freer. One must, I think, attrib-

ute this new technique partly to the effect on Cézanne's oil painting of his painting in water-colour. These water-colour drawings, particularly the large landscapes, become more numerous at this period.

And water-colour was developed by Cézanne in a very new and personal way. He recognized that this medium allows of certain reticences which are much less admissible in oil-painting. In that the smallest statement is definitive. The smallest touch tends to deny the surface of the canvas and to impose on the imagination a plane situated in the picture-space. In water-colour we never can lose the sense of the material, which is a wash upon the paper. The colour may stand for a plane in the picture-space, but it is only, as it were, by a tacit convention with the spectator that it does so. It never denies its actual existence on the surface of the paper. In oil, then, one is almost forced to unite together in an unbroken sequence all the separate statements of colour of the various planes. In water-colour the touches are indications rather than definite affirmations, so that the paper itself may serve as a connecting link between disparate touches of colour.

Here, then, was a favourable condition for the necessity which Cézanne felt so strongly of discovering always in the appearances of nature an underlying principle of geometric harmony. On his sheet of paper he noted only here and there, at scattered points in his composition, those sequences of plane which were most significant of structure; here, part of the contour of a mountain; there, the relief of a wall, elsewhere part of the trunk of a tree or the general movement of a mass of foliage. He chose throughout the whole scene those pieces of modelling which became, as it were, the directing rhythmic phrases of the total plasticity. One might compare the synthesis which Cézanne thus sought for to the phenomenon of crystallization in a saturated solution. He indicated, according to this comparison, the nuclei whence the crystallization was destined to radiate throughout the solution.

Three of the drawings reproduced here will serve to exemplify this. The very slight drawing—pencil with one or two minute washes—(Fig. 30) shows how he begins by only indicating a few significant parts of a contour. This is partly due to his intense desire to avoid isolating any one part from the whole context. He has to carry on the realization of every part on a level front, so to speak. But the extraordinary thing is to note how complete a conception of the whole picture space is given here. Here we are almost able to carry on the indications for ourselves, so pregnant are the hints he gives us.

The same effect is produced in Figs. 31 and 32. In both what strikes one is the potent functioning of every one of these faint indications to stimulate our grasp of the whole nexus of planes which is to build up the finished design.

Where Cézanne uses colour we note that at each nodal point of the interplay of planes, Cézanne marks this sequence by a series of small washes of various colours, modulating generally from violet to greenish, or bluish grey. His aim in this was as far as possible to translate changes of tone into changes of colour, feeling that only by this method could the full saturation and pressure of the colour be realized.

I cannot doubt that this peculiar method which gave such valuable results in water-colour, influenced Cézanne to apply it at least to the early stages of his oil paintings, and that gradually it grew to be his habitual practice in the succeeding period.

In proportion then, as we advance in the chronological sequence of his works, we find his material become less and less pastose, his touches more and more liquid and transparent, more like water-colour. The change is gradual. Nor is it so regular that we can trust to it altogether to fix the exact date of any given work. There are returns to the old impasto, but thin painting certainly predominates towards the end of the century.

And this last decade of the century supplies some of our artist's most celebrated masterpieces. If at times one regrets the loss of the robust sensuality of his enamelled pastes one cannot deny that the "water-colour" method leaves greater freedom to the play of his feeling. He is able by now—and this is also in part a cause of the changed method—he is able to arrive at his synthesis more directly, with fewer corrections and repetitions, without the super-position of so many successive layers of paint. The synthesis seems in fact to be seized more firmly by his imagination and is therefore externalized more directly and with even more impalpable variations of tone.

One of the earliest pictures to give clear evidence of this new method is *La Femme à la cafetière* (Fig. 33). This is ascribed by M. Rivière to the year 1887, a date which is rather surprising in view of the handling which would naturally incline one to a later date. We cannot, however, as noted before, establish a perfectly regular progression in this gradual and unconscious change in Cézanne's method. In any case it opens for us splendidly the series of masterpieces which belong to the closing decade of the century. It is a portrait of the *bonne* of his home at Aix. In sitting for her master, she evidently took the pose which all uneducated people instinctively adopt before the camera. It was like Cézanne in his maturity to accept this without question, without any attempt to arrange things for pictorial effect and to trust to the extraordinary resources of his art to pull him through. He even seems to delight in the rudimentary simplicity of the situation. He does not hesitate to repeat everywhere the perpendiculars, even to the point of putting the spoon and the coffee spout directly facing him, and emphasizing the fastening of the servant's dress by a line which divides the figure symmetrically. All is posed full face and in front of a flat door which also is parallel to the picture plane. It looks almost like a defiant renunciation of all

63

those devices which painters had adopted ever since the High Renaissance to enrich their arabesque and increase the recession of the picture-space. But by this time Cézanne knew his capacities, knew that a flat door could reveal to his searching analysis as many complexities of movement, as great a play of surface, as any object whatever, under the play of light. Thus this extreme platitude in the arrangement ceases to trouble us. The picture-space recedes, and every part has the vibration and movement of life; it is as much removed from schematic dryness and drabness as possible. It is noticeable that the modelling of the hands is very much simplified whereas the surface of the door is infinitely varied. This exemplifies pointedly a constant characteristic of Cézanne, his feeling that the plastic sequence must be felt throughout the whole surface of the canvas. It is natural enough that painters should tend to regard particular parts of a design as more important and expressive than others; should be more intrigued say by a face than by a blank wall behind it, and should therefore give to some parts of their pictures fullness and complexity, whilst they indicate others in a perfunctory fashion. Cézanne's work shows how completely he controlled this inclination. For him, though there might be nodal points in the sequence, every part, however apparently insignificant, had to contribute its precise and irreplaceable quotum to the whole. Every instrument in the orchestra must sound, however faintly. Even in the water-colours where only the key phrases are written down they are felt as setting up rhythms in every part of the surface.

But this perfect continuity of plastic sequences did not of course imply any want of organization. This continuity only contributes to the perfectly lucid organization and the clear articulation of the volumes. Their exact relief or recession has to be given to each plane. Nothing could be more explicit, more legible than the plasticity of this design where everything keeps its

exact position, and where the volumes have the exact space in which to evolve.

The *Portrait of Mme Cézanne* (Fig. 34) dates from the end of the 'eighties, but it is definitely in the new manner. As in the last portrait the situation is of the simplest; we have again the bold symmetry of the model seen full-face and this time almost in the centre of the canvas. There is no attempt to break it by contrasted movement of arms, head or torso; the rigid rectangularity of the chair back is also frankly accepted.

But then, as though this elementary approach to the subject might, by its too primitive, too hieratic simplicity, check the impression of the accident of life, Cézanne has instinctively corrected this in his detailed treatment. Everywhere this symmetry is modified by deformations: the body leans slightly to one side, and the perpendicular of the dado behind becomes drawn into the movement, which is cunningly accentuated by the tongs in the fireplace, and is reinforced by the diagonal of the curtain to the right. The strongly marked edge of the dado seen in perspective affords by its emphasis the counterpoise to these uniform movements. Finally, as though not to break anywhere this general play of slight variations, this dado does not even keep a continuous line, but appears as though refracted where it passes behind the chair. A strange device which Cézanne's sensibility imposed on him—one can see it is no matter of mere carelessness by the extreme precision and deliberation with which the border of the wallpaper and the mouldings are executed—a strange device to avoid the effect of fixity and rigidity which might ensue from the general construction. In the drawing we see Cézanne's tendency to refer all the forms to extremely simple elements and to retain vitality by the minute, impalpable play of the surface and by the quality of the contours. Every particle vibrates, the palpitation of life is revealed in the delicacy and sen-

sitiveness of all these innumerable touches so freely and lightly inscribed on the canvas, to kindle what a smouldering glow of colour! The basis of the whole web of colour is a blue somewhat like Vermeer's, of whom one is reminded again by the opposition of pale yellows something between citron and Naples yellow in the chair-back. The robe gleams with tints of old rose modulated with endless variations of violet, and everywhere the colours are set off by the underlying and unifying blue.

The transposition of all the data of nature into values of plastic colour is here complete. The result is as far from the scene it describes as music. There is no inducement to the mind to retrace the steps the artist has taken and to reconstruct from his image the actual woman posing in her salon. We remain too completely held in the enchantment of this deep harmony. Though all comes by the interpretation of actual visual sensations, though the desire to remain absolutely loyal to them was an obsession with Cézanne, the word realism seems as impertinent as idealism would be in reference to such a creation. It belongs to a world of spiritual values incommensurate but parallel with the actual world. It is an example of what Jules Renard calls *la vérité créatrice d'illusions.*

Of all Cézanne's portraits perhaps that of *M. Geffroy* (Fig. 35) is the most celebrated. Its success must be partly due to the extraordinary number of sittings to which his admiring and clear-sighted sitter submitted. The construction here is more erudite than in the *Mme Cézanne.* It is less removed from the ordinary conception of a portrait arrangement. The movements here are more complex, there is a less complete frontality of presentment and symmetry of design. The equilibrium so consummately achieved results from the counterpoise of a great number of directions. One has only to imagine what would happen if the books on the shelf behind the sitter's head were upright, like the others, to realize upon what delicate adjustments the solidity of this amazing

structure depends. One cannot think of many designs where so complex a balance is so securely held. The mind of the spectator is held in a kind of thrilled suspense by the unsuspected correspondences of all these related elements. One is filled with wonder at an imagination capable of holding in so firm a grasp all these disparate objects, this criss-cross of plastic movements and directions. Perhaps, however, in order to avoid exaggeration, one ought to admit that since Cézanne's day other constructions have been made as complex and as well poised, but this has I think been accomplished at too great a sacrifice of the dictates of sensibility, with too great a denial of vital quality in the forms. And it is due entirely to Cézanne's influence that any such constructions have been attempted. He it was who first, among moderns at all events, conceived this method of organizing the infinite complexity of appearance by referring it to a geometrical scaffolding. Though it must always be remembered that this is no *a priori* scheme imposed upon the appearances, but rather an interpretation gradually distilled from them by prolonged contemplation. There is no suggestion here of a mechanical process: Cézanne's sensibility was so tensely alert that there is no hint of the dryness which might have resulted from so geometrical a construction. The concordance which we find in Cézanne between an intellect rigorous, abstract and exacting to a degree, and a sensibility of extreme delicacy and quickness of response is seen here in masterly action. Such a concordance must be something of a miracle. No wonder that so nice a balance of special gifts, each of them comparatively rare, occurs only at long intervals in the history of art.*

*The word "intellect" in this context perhaps needs some explanation, as it frequently gives rise to misunderstanding in discussions on art. What is here called intellect is not, of course, a purely logical function. All apprehension of formal relations depends on the special sensibility of the artist. To one who is incapable of seeing the significance of formal relations there is no sense in

67

Here at all events Cézanne might, one thinks, for once have felt that he had "realized," so overwhelming is the impression of living reality. Vasari would certainly have expressed it by saying that this was life itself, and no mere imitation, which may be only another way of expressing Cézanne's idea that the artist is the means by which nature becomes self-conscious.

XIV

To the early 'nineties belong a group of pictures which are quite peculiar in Cézanne's work. They are almost the only definitely "genre" pieces of his that exist, if we omit the early *Two Men Playing Cards*. Here, too, the subject is a group of cardplayers which he evidently studied in some humble café in Aix. Here perhaps was the only opportunity possible to so nervous and irritable a man as Cézanne, so easily put off by the least distraction. He could rely no doubt on the fact that these peasants took no notice of him—he was just an "original," an odd old man whom most people thought rather mad but harmless. It was always Cézanne's great ambition to do figure pieces, but the conditions for it were too trying. Portraits were possible no doubt, but only when he could get an entirely humble and submissive sitter. But in this *cabaret* Cézanne seems for once to have found the necessary conditions and he did no less than four pictures of this subject; two of large dimensions and extremely worked out. In

speaking of the perfect equipoise of the structure of this portrait. But an artist's sensibility to form appears as having two almost distinct functions according as it is applied to the correlation of all the separate forms in a design, and as applied to the detailed texture of form, its minor variations and play of surface. In comparing these two one is tempted to use the word intellectual of the former because it demands capacities of an analogous kind to the pure intellect and because artists who have shown this power in a high degree have generally shown their intellectual force in other respects.

the two larger *Cardplayers,* of which Fig. 36 is an example, there are three men at cards and one upright figure behind—in one a young girl is introduced in the background. In the other two, which are very similar, there are only two men at cards sitting symmetrically opposite to each other. Of this composition Fig. 37 is one example—the other is in the Louvre.

It is hard to think of any design since those of the great Italian Primitives—one or two of Rembrandt's later pieces might perhaps be cited—which gives us so extraordinary a sense of monumental gravity and resistance—of something that has found its centre and can never be moved, as this does. And yet there is no demonstrative emphasis on such an idea, it emerges quite naturally and inevitably from a perfectly sincere interpretation of a very commonplace situation.

When one thinks of all the attempts that were made in the nineteenth century by Chassériau, Puvis de Chavannes and Watts to attain this monumental quality, we get a measure of Cézanne's greatness when we see that he alone really succeeded. He alone was sincere enough to rely on his sensations and abandon all efforts at eloquence or emphasis.

The other variant of the design is seen in Fig. 37, and here he seems to have carried the elimination of all but the essentials to the furthest point attainable. The simplicity of disposition is such as might even have made Giotto hesitate to adopt it. For not only is everything seen in strict parallelism to the picture plane, not only are the figures seen in almost as strict a profile as in an Egyptian relief, but they are symmetrically disposed about the central axis. And this again is, as it were wilfully, emphasized by the bottle on the table. It is true that having once accepted this Cézanne employs every ruse to render it less crushing. The axis is very slightly displaced and the balance redressed by the slight inclination of the chair back and the gestures of the two men are slightly, but sufficiently varied. But it is above all by the constant

variation of the movements of planes within the main volumes, the changing relief of the contours, the complexity of the colour, in which Cézanne's bluish, purplish and greenish greys are played against oranges and coppery reds, and finally by the delightful freedom of the handwriting that he avoids all suggestion of rigidity and monotony. The feeling of life is no less intense than that of external stillness and repose. The hands for instance have the weight of matter because they are relaxed in complete repose, but they have the unmistakable potentiality of life.

These figures have indeed the gravity, the reserve and the weighty solemnity of some monument of antiquity. This little café becomes for us, in Cézanne's transmutation, an epic scene in which gestures and events take on a Homeric ease and amplitude.

If, by reason of the helplessness of language, one is forced to search for poetical analogies even to adumbrate at all the emotional effect of this design it is none the less evident that this results from a purely plastic expression. There is here no appeal to any poetical associations of ideas or sentiments. It is a triumph of that pictorial probity which it is the glory of modern art in France to have asserted—its refusal of the assistance which romantic interpretations offer. And the reward of this difficult attempt is seen here, for Cézanne's purely plastic expression reaches to depths of the imaginative life to which consciously poetical painting has scarcely ever attained. What a fortunate fatality it was that barred for Cézanne that ambition which gave rise to his *Lazarus* and *Autopsy* and the other, too deliberately expressive, conceptions of his early years.

XV

Fig. 38 gives an idea of the landscapes of the beginning of this period. The rectangularity of the design is here pushed very far, so far indeed that in the reproduction there seem scarcely

any sequences of form that can intrigue the eye. But those who saw the original when it was exhibited recently at the Leicester Galleries will recall the exhilaration which it gave by the shimmering intensity of its interwoven colour, by the astonishing felicities of its transitions, its unexpected and seductive harmonies.

It is rather to the early part of the period, the end of the 'eighties that we owe the greatest output in this genre. It was at this time that Cézanne devoted himself so constantly to interpreting that part of the countryside near Aix that is dominated by the great buttressed ridge of Mt. Ste Victoire. It is a mountain that impresses one rather by the strangeness of its "personality" than by its height or its precipitousness. It must have exercised a peculiar fascination for Cézanne, for no mountain has ever been explored by an artist so persistently, so incessantly as this. His interpretation is extremely personal; he seized always upon two or three elements of its formal structure and almost ignored what is, to a superficial view, its most marked peculiarity, namely the succession of parallel buttresses along its southern summit. It is characteristic of Cézanne's method of interpreting form, thus to seize on a few clearly related, almost geometrical elements, and then on top of this clearly held framework, to give to every part of the contour the utmost subtlety of variation which his visual sensibility could discover and his nervous drawing record.

What is remarkable, too, in these landscapes, in which the eye takes in a vast stretch of undulating country leading up to the crowning pyramid, is the extraordinary power our artist shows of holding together in a single rhythmic scheme such an immense number of small and often closely repetitive movements. Usually this wide vista is framed by a *repoussoir* of pine branches leaning across the sky. At times with a daring which no longer surprises us he will allow the curves of a pine branch to follow almost exactly the contour of the hills seen beneath it.

The example given in Fig. 39 does not show this disposition,

though it exemplifies well Cézanne's method at this period. As compared with earlier landscapes one feels that there is a greater ease, a freer play over the surfaces. Structure is still the primary consideration, it still prevails over the "impression," but those accents which clamp the structure together no longer need to be so heavily insisted on, the atmosphere becomes freer, lighter and more exhilarating.

We find in *La route du Château Noir* (Fig. 40) a type of the landscape of the 'nineties. The only available photographs of this picture unfortunately deform it seriously. The effect of the picture is decidedly light and gay. It is the full Mediterranean light, and nothing in it suggests the almost melodramatic effect which defective photography has caused. Here the "crystallization" of the forms is complete. The planes interjoin and interpenetrate to build a design where the complexity does not endanger the lucidity of the relations. Not only has Cézanne's notion of plasticity and of the plastic continuity here attained its plenitude, but the artist controls it with perfect freedom. If we compare it to the works of the early maturity—those of 1877 for instance—we see how far Cézanne has developed in this direction, how much more he feels at his ease before the "motive," how much sooner he dominates and controls it. By now he is able to trust much more to the habitual inclinations of his sensibility and to his acquired science. Not only have the forms been reduced to those elements with which we are familiar, but here also the colour has become increasingly systematic. He modulates in the chosen chromatic key almost as a musician does. He accepts from nature, not so much the precise indications as before, but rather suggestions of modulations which he then renders according to the progressions of his scale. It must be understood that this is only a difference of degree; what we have here is only a freer and bolder use of the method of his earlier work. It implies that he can by now modulate with such suppleness and with so rich a

variety of transitions, that he can give the feeling of living reality by a still more generalized interpretation of the actual vision. Cézanne himself was fond of this word, using "modulate" instead of "model," and it is one of many indications of how clear sighted he became in his maturity about the essential bent of his own genius.

If with regard to the quality in question, we compare this land-scape with the *Compotier* we find that in that he analyses minutely all the colour elements in a given surface. Naturally when he expressed the results of this analysis his sensibility intervened, but only to introduce those minute adjustments which were necessary to achieve a definite interpretation. Here the appearance of a minute analysis is illusory. Cézanne respects far less obediently the data of the actual sensation. Thus we find almost every plane modulated in the same colours employed in different proportions. Here the contours and shadows are almost always greyish blue hatched with violet lakes. Then we have emerald green and cobalts, rare touches of cadmium greens and a whole series of oranges passing from ochre almost to vermilion.

We find then here the same economy in colour that we are familiar with already in Cézanne's form—the colour also is "geometric." The impression of the infinity of nature is none the less re-established by the subtlety and vivacity with which the changes are rung on these carefully selected elements. This heightened vivacity is due in part to a change in Cézanne's handwriting, for that too has become freer and moves with a more elastic rhythm. Cézanne shows himself here completely the master of his new "water-colour" technique. Indeed the comparison with water-colour becomes here more justifiable, for he is able to leave large parts of the white canvas preparation intact. The touches of colour are often spaced out upon it. And yet if we view the canvas from the proper distance the effect of plastic continuity is complete. We recognize the relief and recession of each plane. The

picture, with all the gaps in the colour, is completely finished. Cézanne has realized his early dream of a picture not only controlled but inspired by the necessities of the spirit, a picture which owes nothing to the data of any actual vision; but this he has achieved by a different route from that which first attracted him. It lies not by way of willed and *a priori* invention, but through the acceptance and final assimilation of appearance.

XVI

Once more at the end of the century there supervenes a new phase in Cézanne's art. It is more difficult to be precise about this than about the previous phases, partly because the pictures are rare and less accessible, and have not been adequately photographed, partly because it includes considerable variations. Thus in some ways it shows a continuance of the water-colour technique, an even extended use of pure transparent glazes of colour; in other examples there is a return to impasto laid on to the preparation directly, in loaded brush strokes. In those in which glazes predominate broad washes of colour tend to replace the hatchings of his penultimate period. The colour is again simplified and also greatly intensified. There are canvases in which pure transparent cobalts predominate, accompanied by pure deep viridians and intense oranges. The colour thus attains to incredible depth and saturation, and the handling is freer than ever.

But whatever the technique we find in this last phase a tendency to break up the volumes, to arrive almost at a refusal to accept the unity of each object, to allow the planes to move freely in space. We get, in fact, a kind of abstract system of plastic rhythms, from which we can no doubt build up the separate volumes for ourselves, but in which these are not clearly enforced on us. But in contradistinction to the earlier work, where the articulations

were heavily emphasized, we are almost invited to articulate the weft of movements for ourselves.

This description is suggested by a picture belonging to M. Vollard, which represents a road plunging from the immediate foreground into a wood of poplars, through which we surmise the presence of a rock face, which rises up behind and dominates the tree tops with its crenellations. Here the disintegration is pushed to such a point, the volumes are so decomposed into small indications of movement scattered over the surface, that at first sight we get the impression of some vaguely patterned carpet or embroidery. But the more one looks the more do these dispersed indications begin to play together, to compose rhythmic phrases which articulate the apparent confusion, till at last all seems to come together to the eye into an austere and impressive architectural construction, which is all the more moving in that it emerges from this apparent chaos. It is perhaps in works like these that Cézanne reveals the extraordinary profundity of his imagination. He seems in them to attain to heights of concentration and elimination of all that is not pure plastic idea, which still outrange our pictorial apprehension. If for us, the great masterpieces of the penultimate period like the *Cardplayers* and the *Geffroy* remain the supreme achievements of Cézanne's genius, one may none the less have a suspicion that for certain intelligences among posterity, the completest revelation of his spirit may be found in these latest creations.

In all of these latest landscapes one notices above all this intense concentration. All is reduced to a single motive. Sometimes it is Mt. Ste Victoire, which raises its pyramid from a succession of ridges, and all is agitated by infinitesimal modulations and impalpable movements. Sometimes it is the orange cube of the Château Noir, which gleams through an inextricable tangle of fir trees and scrub. Every particle is set moving to the same all-pervading rhythm. And the colour, sometimes exasperatedly

intense, sometimes almost uniform in its mysterious greyness, upholds the theme by the unity of its general idea, the astonishing complexity and subtlety of its modulations. One feels that at the end Cézanne reposed a complete confidence in the instinctive movements of his sensibility, broken as it was by the practice of a lifetime to the dictates of a few fundamental principles. Something of the character of the pictures just described may be divined from the water-colour reproduced here (Fig. 41), for by now Cézanne's oils and water-colours have become extremely similar. It gives a notion of the freedom and uniformity of his almost agitated movements.

It would appear that there was at the end of Cézanne's life a recrudescence of the impetuous, romantic exuberance of his early youth. It is deeply affected and modified by the experience of the intervening years. There is nothing wanton or wilful about it, nothing of the defiant gesture of that period, but there is a new impetuosity in the rhythms, a new exaltation in the colour. This is of course a well-known phenomenon among artists who live to an advanced age. Titian's is the classic example.

The pictures cited above represent the extreme of this latest manner of our artist. The landscape (Fig. 42) shows its more normal quality, and here, without being able to study the intensity of the colour, the flash of oranges and reds against pure greens, violets and cobalts, one can scarcely appreciate its peculiarities: one can only mark the more restless movements, the choice of a less frontal aspect of the main surfaces.

The landscape (Fig. 43) of a pool overhung with foliage gives an idea of the disintegration of volumes of which I have spoken. It is quite true that in nature such a scene gives an effect of a confused interweft, but in earlier days Cézanne either would not have accepted it as a motive or would have established certain definitely articulated masses. Here the flux of small movements is continuous and unbroken. We seem almost back to the attitude

of the pure Impressionists. But this is illusory, for there will be found to emerge from this a far more definite and coherent plastic construction than theirs. It is no mere impression of a natural effect, but a re-creation which has a similar dazzling multiplicity and involution.

XVII

The portrait of his gardener, *Vallier* (Fig. 44), is typical of a good many portraits of these years. Here again the aspect chosen is less frontal, there is a free sweeping emphasis in the contours very different from the precision and austerity of the *Geffroy*. The picture is deep in tone and rich with the sombre glow of indigos, broken with violet and green, and contrasted with rich earth reds and oranges.

Once more, at this moment of recrudescent romantic emotion Cézanne was haunted by his old dream of the *a priori* creation of a design which should directly embody the emotions of his inner life. This desire took the form of a vast design of naked women seen under a canopy of foliage. There are several canvases, some of colossal size, devoted to his repeated essays in this direction. Two of these are reproduced in Fig. 45 and Fig. 46. Fig. 45 is of monumental dimensions and belongs almost to the close of the century. Fig. 46 is of the last period. A comparison of the two shows great changes. The colour in the earlier version is gay and almost light, in the latter the blues have become heavy with successive glazes and the flesh tones are rich and glowing. There is also a considerable change in the forms. The earlier version gives us perhaps the nearer approach to what Cézanne was aiming at in his repeated essays. The point of departure is the pyramid given by the inclined tree trunks on either side. The poses of the figures are clearly dictated by this—too clearly, too obtrusively indeed do they adapt themselves to this elementary schema. In

spite of the marvels of his handling and the richness and delicacy of the colour transitions he has not escaped the effect of dryness and wilfulness which so deliberate a formula arouses.

It is touching to see the unyielding pertinacity with which Cézanne returns again and again to the attack, to his old effort to overcome his fundamental inaptitude for invention: thus up to the end, obsessed by the idea of rivalling a Titian or at least a Delacroix, he refused to accept his own limitations and to take his place among those great imaginative artists to whom some actual vision is necessary as a point of departure.

In the later version of this theme there is an attempt to avoid the extreme symmetry of the earlier, though the constant repetition of the same two balancing diagonal directions persists. But the individual forms of the figures have become even more disconcerting. For so many years Cézanne's fear of the model had deprived him of all observation of nature that his power of conjuring up a credible image to his inner eye, never remarkable, has by now become extremely feeble. He is forced to fall back on general ideas in order to construct his figures. It cannot be denied that the result is calculated to outrage our notions of feminine beauty. These bodies have become almost geometric abstractions with which he seeks desperately to establish significant combinations. Two or three poses of which he retained a vague memory have to do duty again and again in these compositions. He varies and combines them in different ways, but without ever, it would seem, arriving at a result which satisfies him.

Those of us who love Cézanne to the point of infatuation find, no doubt, our profit even in these efforts of the aged artist; but good sense must prevent us from trying to impose them on the world at large, as we feel we have the right to do with regard to the masterpieces of portraiture and landscape.

But to correct the rather disparaging account which I have given of these works, I must cite a smaller design of the same

subject which belongs to M. Vollard. It is, I believe, his last effort to lay this old obsession. Here, too, the trees incline from either side to frame a large expanse of sky and distance in front of which the nude figures appear. Here the dimensions of the canvas did not force Cézanne to attempt an almost sculptural relief in his figures such as the monumental scale of the others had done. The nude figures are conceived in a more purely pictorial vein, the forms only indicated with a rapid and almost elegant touch, with the result that they enter easily into the general movement of the landscape. They are expressed with the same spontaneity and freedom of handling. In this way Cézanne has attained a much greater variety of poses with the happiest result. The dominant lines are still strongly marked, but the geometric scheme is more freely varied. Thus liberated from a cramping pre-occupation Cézanne regains all the prestige of his chromatic sensibility. The dominant harmony is a pearly grey, which modulates now into faded *eau de Nil,* now into the faintest roses, and against this play the more golden greys of the flesh. Throughout, it shows an elusive subtlety of colour which has extraordinary charm, and agrees well with a tonality reminiscent of fresco painting.

XVIII

These repeated attempts at compositions with a definite lyrical intention reveal a curious idiosyncrasy in Cézanne's temperament, namely his attitude to women. One cannot doubt that throughout his life Cézanne was violently drawn to the female form as a motive. His plastic feeling would alone have urged him to the contemplation of forms so eminently suited to embody his ideas, his love of ample, simply defined volumes. But there can be no doubt that this feeling was complicated in a curious way by his eroticism. This in turn was violently checked by his well-attested terror of women. The conflict produced a curi-

ous inhibition—he simply did not dare to draw from the nude model. From time to time, however, he found models sufficiently deprived of charm to satisfy him, though he was never altogether at ease in their presence. One of the rare nudes thus studied directly from nature is given in Fig. 48. Apart from a certain want of assurance in the poise of the figure there are parts, especially in the torso, which are sensitively interpreted. It makes us recognize how great a loss to his art this peculiar idiosyncrasy entailed. How much more completely, but for that, he might have realized the conception of the great "poesies" of the last period.

What renders this strange caprice of Cézanne's temperament so serious is that he could not any the more rid himself of those obsessing images, and was therefore condemned to wrestle perpetually with the problem of giving them external expression. At times he even tried to revenge himself by satirical designs of a disconcerting kind. This is the case for instance in *La Femme* (Fig. 49) where on a monumental couch, the so redoubtable figure of Woman is represented. She is purposely reduced to a condition of elementary bestiality and flaunts herself before all the different types of humanity who gather in adoration before her seductive power. One has to admit that Cézanne was singularly unfitted for such an enterprise. He was incapacitated as always by his want of the gift to conjure up for his inner vision characteristic types and to give them the verisimilitude which is essential for such psychological expression. There is nothing here to give us aesthetic pleasure except his unfailing quality of handling and his colour harmony.

One notes here a peculiarity which is constant in almost all Cézanne's inventions. The composition is based on a regular pyramid placed in the centre of the canvas. We have noticed this already in the large "poesies," and we find it again in the group shown in Fig. 51. This, by the by, is one of his happiest efforts in such inventions. The aggressive symmetry is broken by the figure

to the right, and the forms are disposed in happily varied and harmonious sequences, the quantities of the volumes are adjusted to the space and beautifully co-ordinated. If it is lacking of completeness as a pictorial design, it would at least make a remarkable sculptural relief.

In the composition of designs arising from an internal stimulus Cézanne shows, then, a curiously restricted power. He has at his command only this one elementary framework. And what makes this so unexpected is that it contrasts so forcibly with his gifts as a composer when the stimulus was an external vision. There have been indeed very few artists who have created so many entirely original and rigidly compact compositions as Cézanne. He scarcely ever lapses into what is casual or accidental or fails to bring every part of the canvas into organic relation with the central theme. It is curious that an artist so fertile in resource before the given scene should have been at such a loss before the blank canvas. This peculiarity is however so strongly marked that I cannot help suspecting, in these pictures, where there is an appearance of easier, more felicitous invention, that the design has generally been taken from another work of art. I suspect it for instance in the exquisite sketch of a nude woman before a mirror (Fig. 50), which has a great resemblance to a Delacroix belonging to M. Paul Rosenberg.

I suspect it, too, in most of the many versions of the *Temptation of S. Anthony,* of which a good example is given in Fig. 52. It was natural that Cézanne, given the peculiarities of his erotic feeling, should have constantly turned to this theme which was the classical expression of those attractions and repulsions under which he laboured. In this version the design is admirably balanced, the richly varied movements are splendidly controlled and the plastic motive is everywhere sustained by a nervous and impetuous handling. I can hardly doubt though that Cézanne was helped over the initial difficulties of invention by some existing

composition. The beautiful poses of the nude figure and the mischievous *putti* suggest irresistibly some Italian of the seventeenth century—so, too, does the theatrical gesture of the Saint, so foreign in its complicated movement to the poses which naturally occurred to Cézanne.

It is to be noted in these inventions, that it is when he seeks to give to his idea its complete realization, when he endeavours to give the sculptural values to his nudes, that he is most hampered by the exigency of his data. In proportion as he contents himself with purely pictorial suggestions of movement and modelling he captivates us by the magic of his touch and the rich harmony of his colour.

Thus there exists a number of small compositions which have an extraordinary freshness and delicacy of feeling, a flowing suavity of rhythm and a daintiness of colour which reminds one of the masterpieces of the eighteenth century. It is the expression of a mood that surprises one by its almost playful elegance in a temperament that for the most part was so grave, so austere and so little attracted by the factitious.

The exquisite little *Toilet* (Fig. 53), reminiscent of the Venetians, is an example, or still later the *Sancho Panza* (Fig. 54), which is as happy as it is unexpected in the disposition of the figures. These moreover are conceived in such perfect concordance with the landscape, the rhythmic feeling is so unbroken and all-pervading that Cézanne's peculiar lyrical emotion emerges clearly.

All the same these exquisite improvisations, much as we should miss their absence, do not form an important part of Cézanne's contribution to our spiritual inheritance. Other and minor masters have been more felicitous in the expression of such eroticolyrical moods. But the persistence of such emotions throughout his life, their increasing attraction towards its close, throw an interesting light on the character of his genius. Cézanne counts

pre-eminently as a great classic master. We may almost sum him up as the leader of the modern return to Mediterranean conceptions of art—his saying that he wished to "do Poussin again after nature" is no empty boast. Cézanne then was a Classic artist, but perhaps all great Classics are made by the repression of a Romantic. In this respect we find a curious parallel to Cézanne in Flaubert. These two men indeed, though so isolated, were both typical of a certain aspect of the spiritual process of the nineteenth century, and though so different in character, described in their lives such similar curves that the comparison between them is not altogether unilluminating. Both were children of the Romantic movement, both shared the sublime and heroic faith in art which that movement engendered, its devotion and absolutism. Both found their way by an infinitely laborious process out of the too facile formulae of their youth to a somewhat similar position, to an art based on passionate study of actual life, but ending in a complete transformation of its data. Both were fortunately entrenched in the solid position of a modest but assured income which enabled them to brave the violent storms of indignation which each, in his own line, provoked, not indeed from any desire for advertisement, or self-assertion, but as an inevitable result of following the dictates of aesthetic expression. Without this accidental protection it is unthinkable that either should have been able to function. But that condition being given, the perfect devotion of their lives to an idea, their utter disregard of all recognition by the world, have in each case something of heroic magnanimity. They are both protagonists in that thrilling epic of individual prowess against the herd which marks the history of French art in the nineteenth century. And both have become in a sort the patron saints of their Confraternities.

In this essay I have tried to press as far as I could the analysis of some typical works of Cézanne. But it must always be kept in mind that such analysis halts before the ultimate concrete reality

of the work of art, and perhaps in proportion to the greatness of the work it must leave untouched a greater part of its objective. For Cézanne, this inadequacy is particularly sensible and in the last resort we cannot in the least explain why the smallest product of his hand arouses the impression of being a revelation of the highest importance, or what exactly it is that gives it its grave authority.

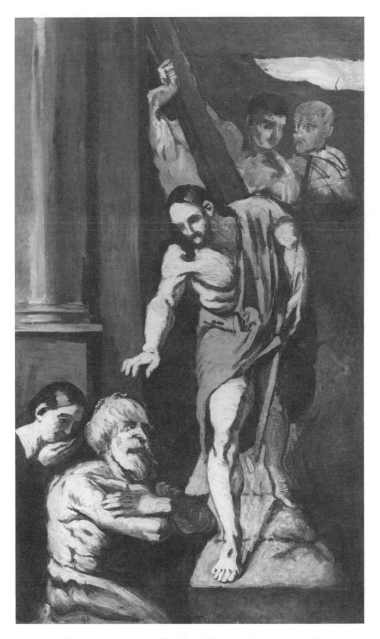

1. Raising of Lazarus. Private collection. Photograph courtesy of the Musées Nationaux.

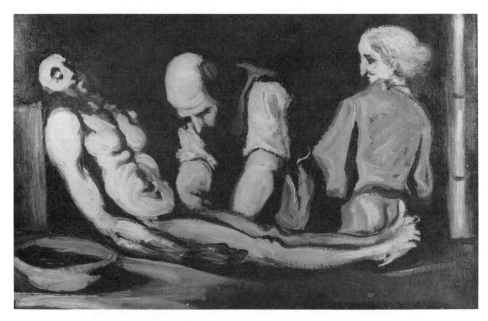

2. The Autopsy. Private collection. Photograph courtesy of the Musées Nationaux.

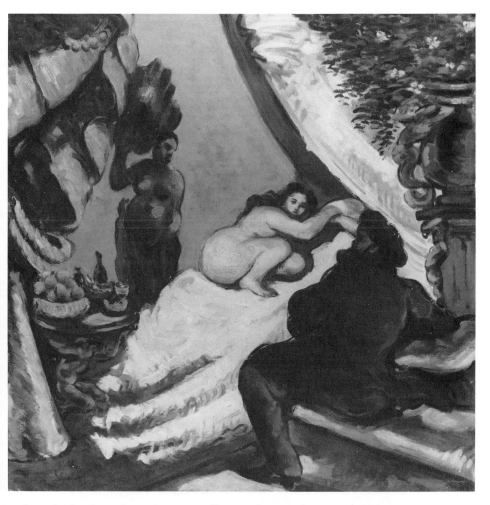

3. The Pasha (Modern Olympia). Private collection. Photograph courtesy of the Musées Nationaux.

4. Portrait of the Artist's Father. National Gallery of Art, Washington, D.C.
Collection of Mr. and Mrs. Paul Mellon.

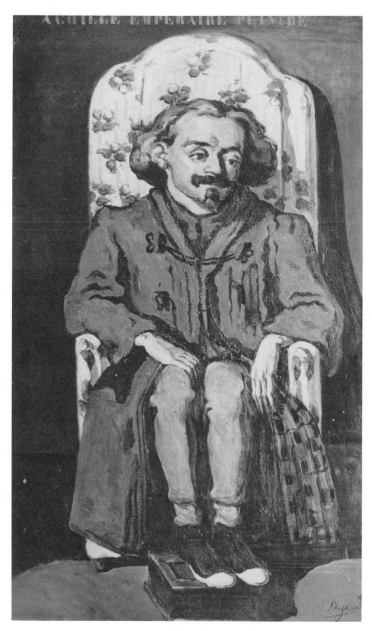

5. Achille l'Emperaire (Achille Emperaire). Musée d'Orsay. Photograph courtesy of the Musées Nationaux.

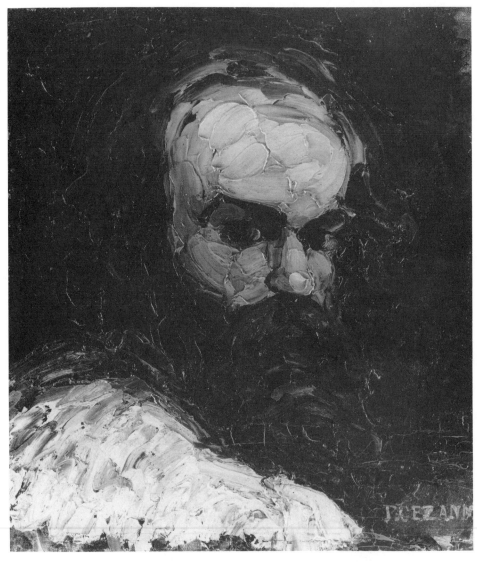

6. Head of Bearded Man. Private collection. Photograph courtesy of the Musées Nationaux.

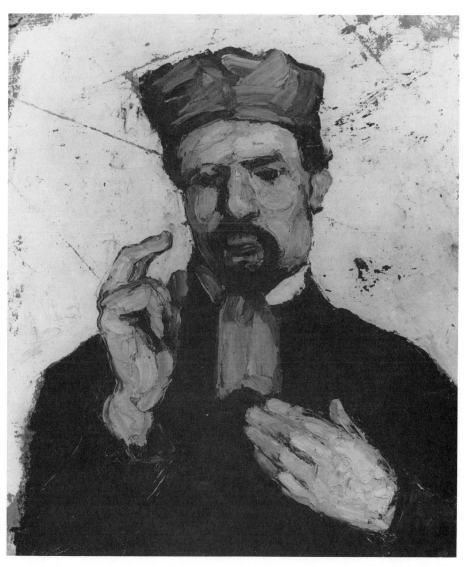

7. An Advocate in his Robes. Private collection. Photograph courtesy of the Musées Nationaux.

8. Portrait of the Artist. Musée d'Orsay — Galerie du Jeu de Paume. Photograph courtesy of the Musées Nationaux.

9. Les Quais. Private collection. Photograph courtesy of the Musées Nationaux.

10. Pastoral. Musée du Louvre. Photograph courtesy of the Musées Nationaux.

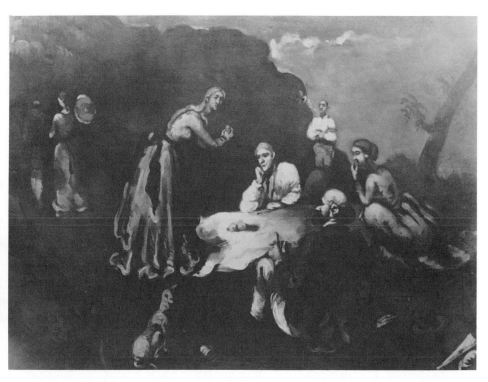

11. A Picnic. Musées Nationaux, photograph by Jim Strong.

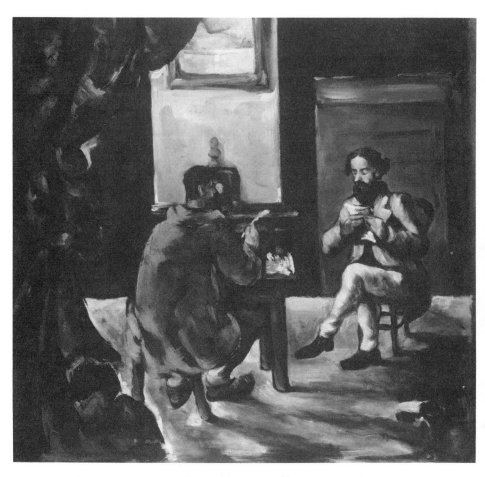

12. Two Men Playing Cards (Lecture chez Zola). Private collection, Switzerland.

13. Sketch of Two Men. Private collection. Photograph courtesy of the Musées Nationaux.

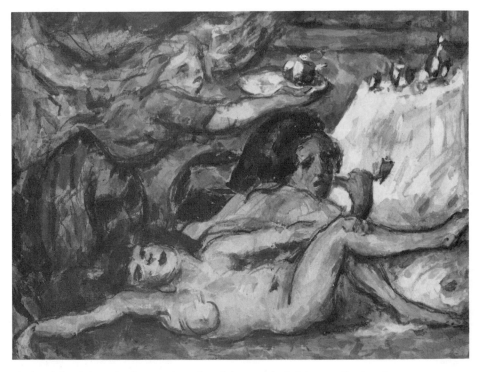

14. L'Après-midi à Naples (Le Punch au rhum) (watercolor). Private collection, Stuttgart.

15. Auvers (Louveciennes). Private collection. Photograph courtesy of Wildenstein & Co., Inc.

16. Le Compotier (Compotier, verre, et pommes). Private collection, New York City.

17. Still-life with a Ginger Jar (Still Life with Basket). Musée d'Orsay. Photograph courtesy of the Musées Nationaux.

18. Still-life with a Soup-tureen and Bottle. Louvre — Jeu de Paume. Photograph courtesy of the Musées Nationaux.

19. Still-life with a Cineraria. Private collection, Switzerland.

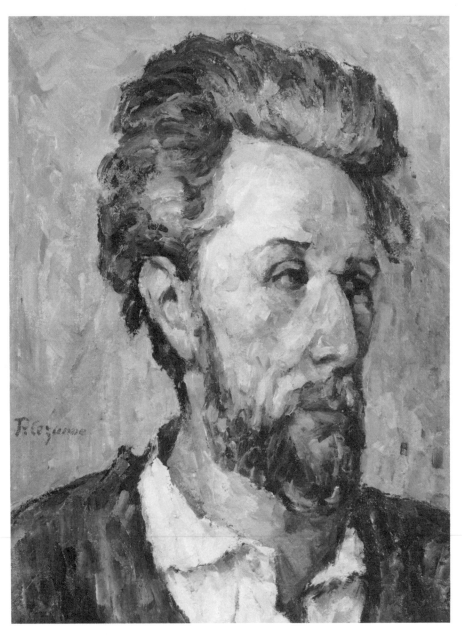

20. Portrait of M. Choquet. Private collection, photograph by Eric Pollitzer.

21. Portrait of Mme Cézanne (Mme Cézanne in a Red Armchair). Courtesy Museum of Fine Arts, Boston. Bequest of Robert Treat Paine, 2nd, 1944.

22. The Provençal Mas (Houses in Provence). National Gallery of Art, Washington, D.C. Collection of Mr. and Mrs. Paul Mellon.

23. Gardanne. Photograph © 1989 by The Barnes Foundation.

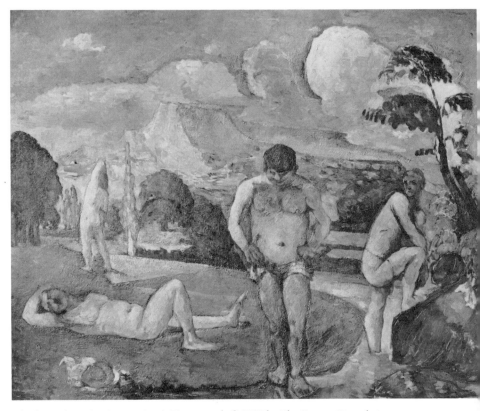

24. The Bathers (Bathers at Rest). Photograph © 1989 by The Barnes Foundation.

25. Provençal Landscape. Fujii Gallery, Tokyo.

26. Maisons au bord de la Marne. Musées Nationaux, photograph by Jim Strong.

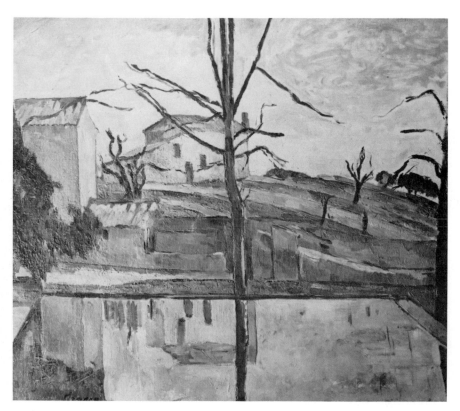

27. Winter Landscape. Musées Nationaux, photograph by Jim Strong.

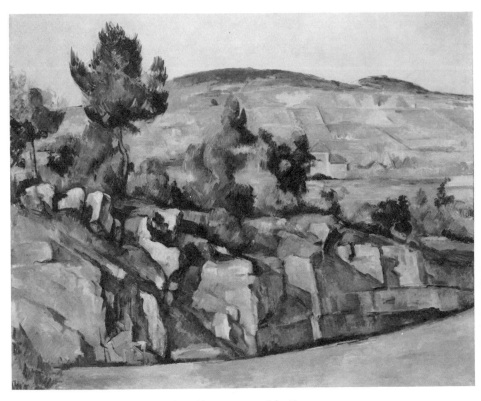

28. Mountains in Provence. Reproduced by courtesy of the Trustees,
The National Gallery, London.

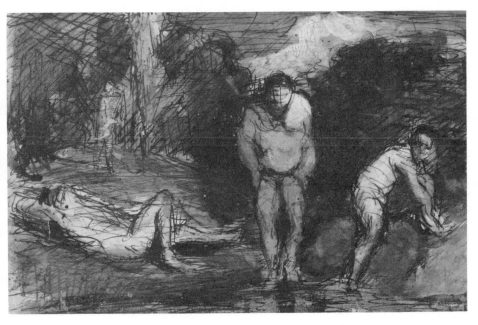

29. Study for the Bathers (fig. 24) (Study for Bathers at Rest) (watercolor).
Bridgestone Museum of Art, Ishibashi Foundation, Tokyo.

30. Tournant de route dans un bois (watercolor). Whereabouts unknown.

31. La Montagne Ste Victoire avec viaduc (watercolor). Private collection, Switzerland.

32. House in Provence (watercolor). Collection of Mr. and Mrs. Henry Pearlman.

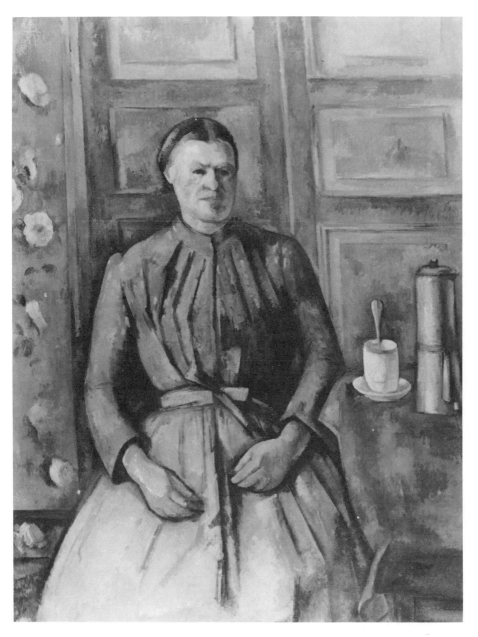

33. La Femme à la cafetière. Musée d'Orsay. Photograph courtesy of the Musées Nationaux.

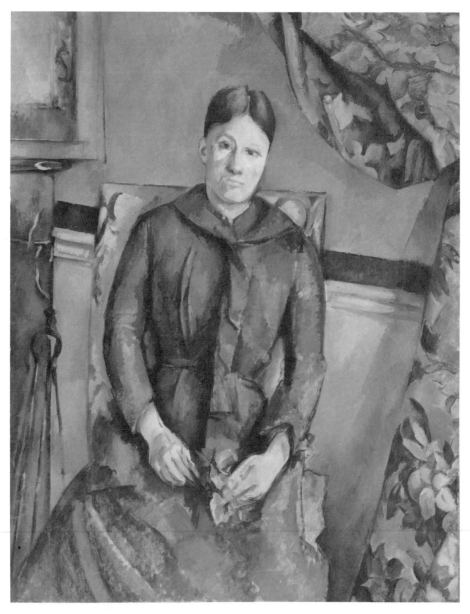

34. Portrait of Mme Cézanne (Mme Cézanne in a Red Dress). The Metropolitan Museum of
Art. Purchase, Mr. and Mrs. Henry Ittleson, Jr. Fund, 1962.

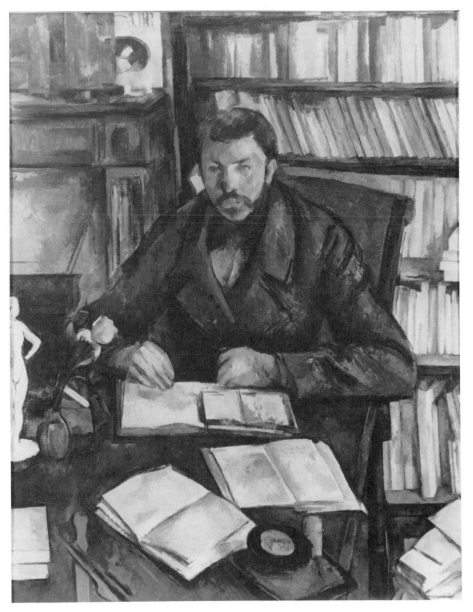

35. Portrait of M. Geffroy (Portrait of Gustave Geffroy). Private collection. Photograph courtesy of the Musées Nationaux.

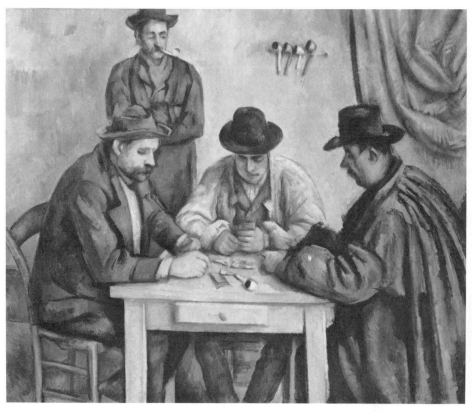

36. The Cardplayers. The Metropolitan Museum of Art. Bequest of Stephen C. Clark, 1960.

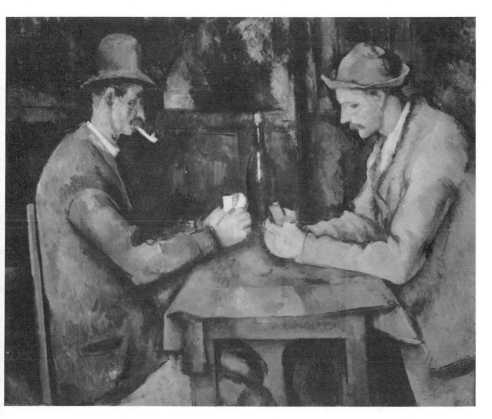

37. The Cardplayers. Musées Nationaux.

38. Environs du Jas de Bouffan. Private collection, Switzerland.

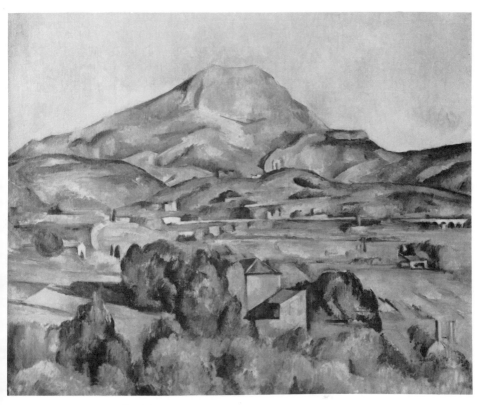

39. Valley of the Arc. Photograph © 1989 by The Barnes Foundation.

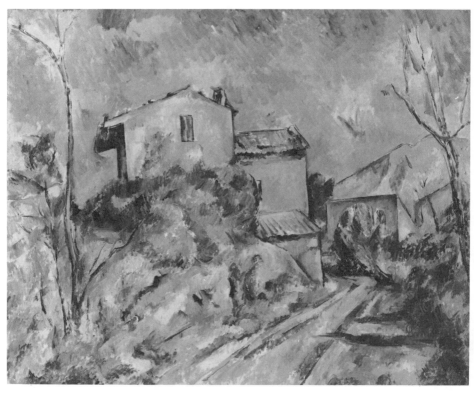

40. La Route du Château Noir (Maison Maria on the Château Noir Road). Kimbell Art Museum.

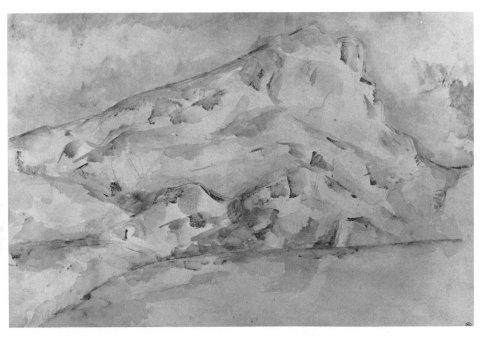

41. La Montagne Ste Victoire (watercolor). Musée d'Orsay. Photograph courtesy of the Musées Nationaux.

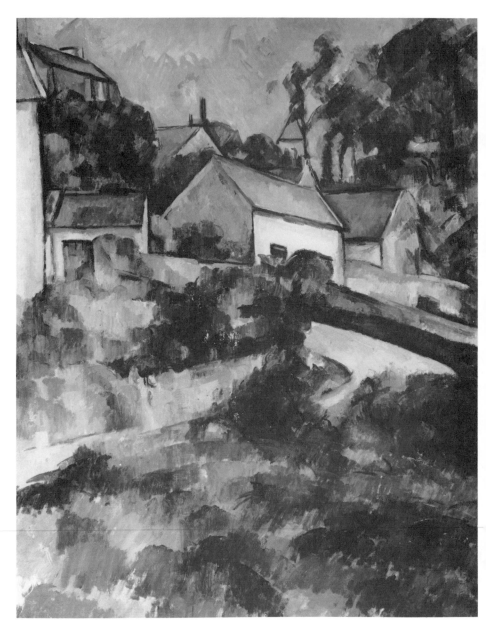

42. Landscape, Houses on a Wooded Slope. Collection of Mrs. John Hay Whitney.

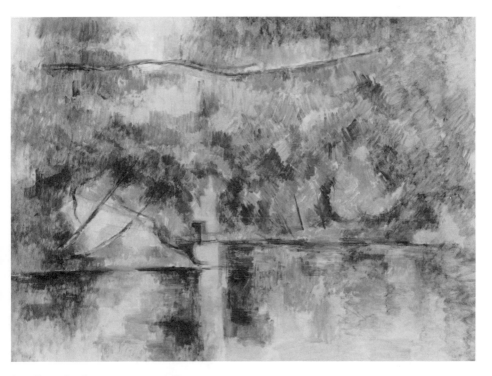

43. Effect of Reflections. Private collection.

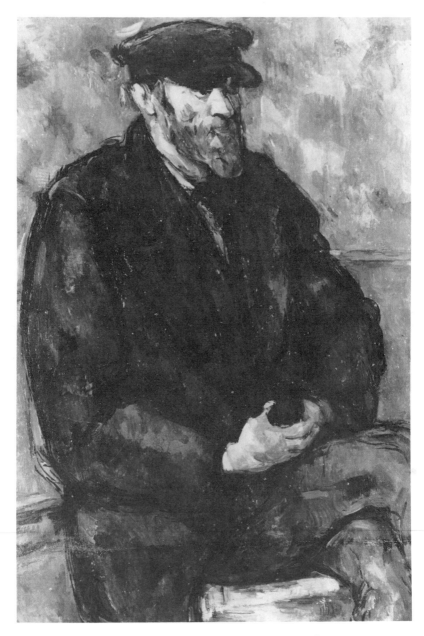

44. Portrait of Vallier. Private collection. Photograph courtesy of the Musées Nationaux.

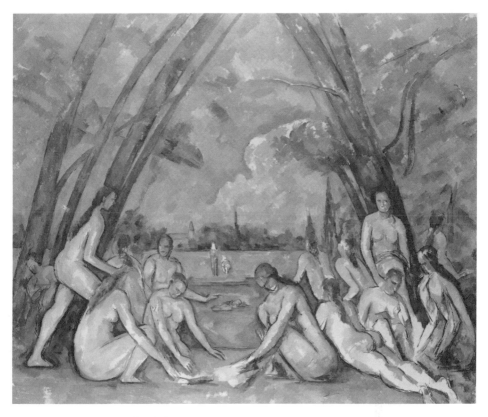

45. The Large Bathers. Philadelphia Museum of Art. Purchased: W. P. Wilstach Collection.

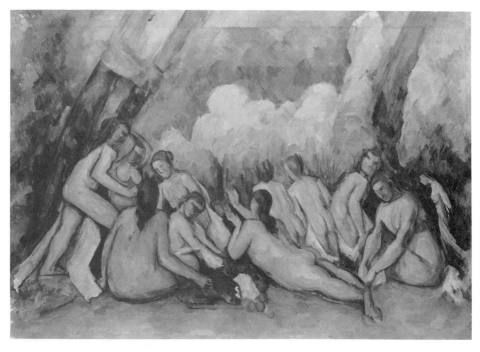

46. Bathers. Reproduced by courtesy of the Trustees, The National Gallery, London.

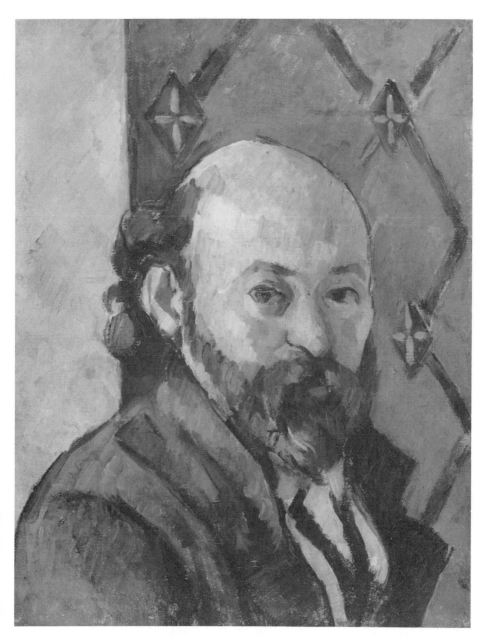

47. Self-portrait. Reproduced by courtesy of the Trustees, The National Gallery, London.

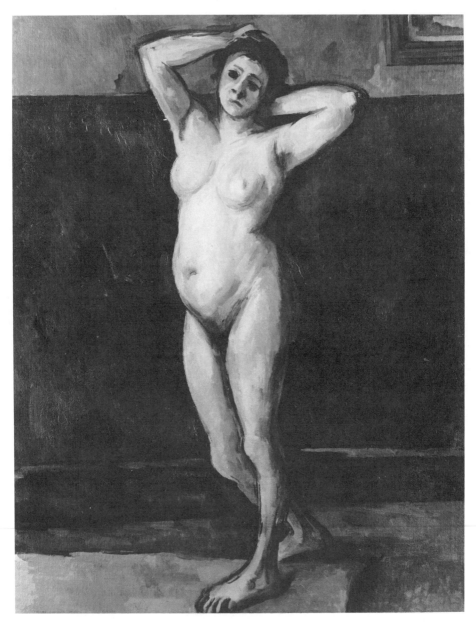

48. Nu féminin. Private collection. Photograph courtesy of Wildenstein & Co., Inc.

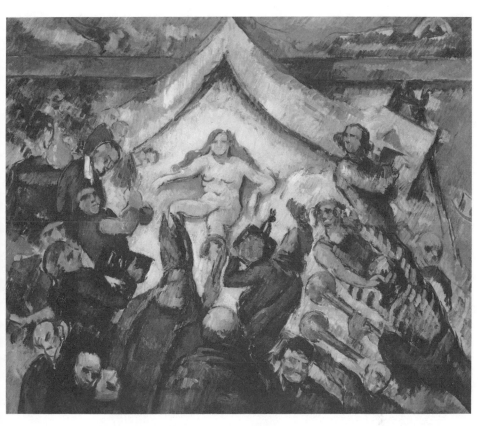

49. La Femme (L'éternel féminin). The J. Paul Getty Museum.

50. Interior with Nude. Photograph © 1989 by The Barnes Foundation.

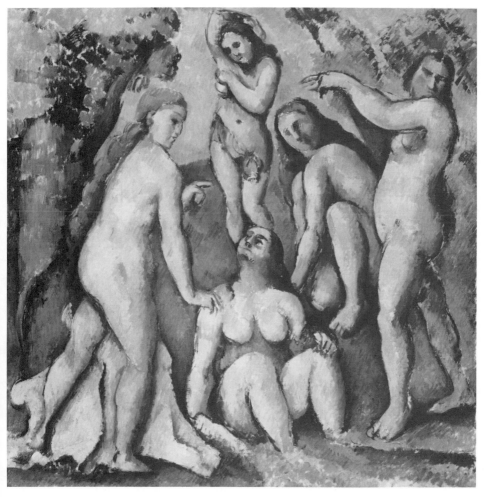

51. Cinq Baigneuses. Oeffentliche Kunstsammlung Basel, Kunstmuseum.

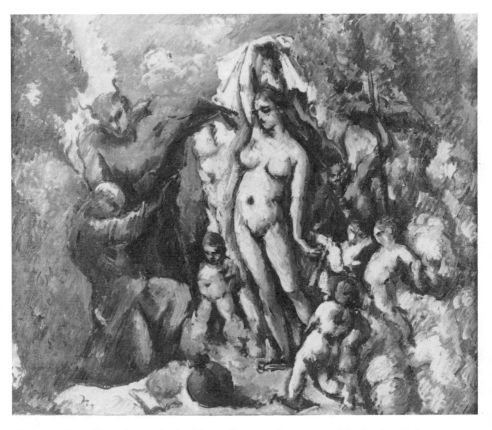

52. Temptation of St. Anthony. Musée d'Orsay. Photograph courtesy of the Musées Nationaux.

53. The Toilet. Musée d'Orsay, photograph by Jim Strong.

54. Sancho Panza (Sancho dans l'eau). Private collection. Photograph courtesy of Wildenstein & Co., Inc.